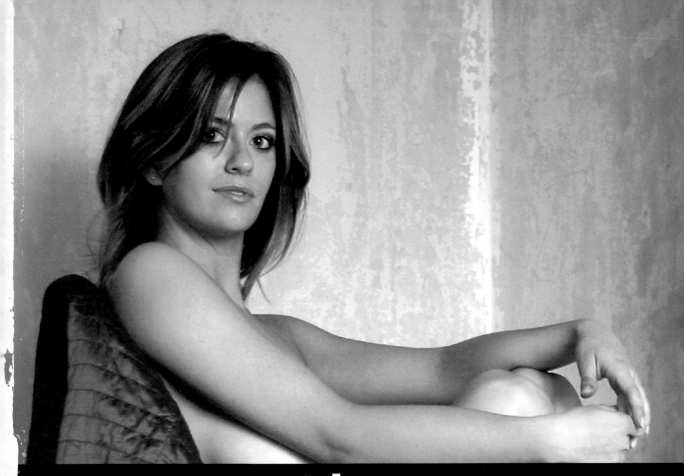

erotic
home photography

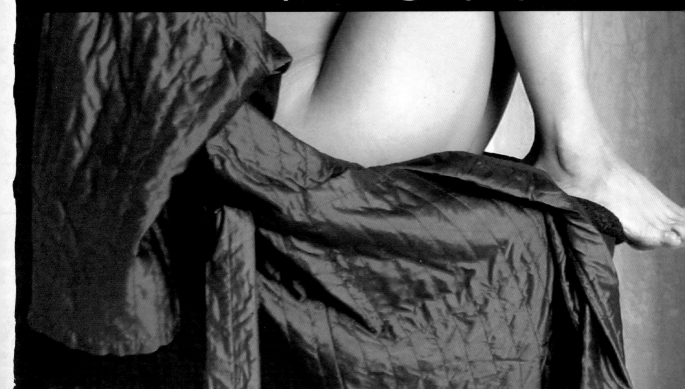

A FIREFLY BOOK

Published by Firefly Books Ltd. 2004

Text and photography copyright © 2004 Tom Ang
Design copyright © 2004 Carlton Books Limited

First Printing

Publisher Cataloging-in-Publication Data (U.S.)

Ang, Tom
 Erotic home photography : how to take your own
nude portraits / Tom Ang ; with Wendy Ang._1st ed.
[128]p. : photos. (chiefly col.) ; cm.
Includes bibliographical references and index.
Summary: Practical guide that shows couples how to
take nude and erotic photographs with conventional
and digital cameras at home.
ISBN 1-55297-956-3
1. Photography of the nude—Handbooks, manuals,
etc. 2. Photography, Erotic — Handbooks, manuals,
etc. I. Ang, Wendy. Title.
778.9/21 22 TR674.A64 2004

National Library of Canada Cataloguing in Publication

Ang, Tom
 Erotic home photography : how to take your own
nude portraits / Tom Ang ; with Wendy Ang.
Includes bibliographical references and index.
ISBN 1-55297-956-3
 1. Photography of the nude—Handbooks, manuals,
etc. I. Ang, Wendy, 1956- II. Title.
TR674.A55 2004 778.9'21 C2004-900139-6

Published in the United States in 2004 by
Firefly Books (U.S.) Inc.
P.O. Box 1338, Ellicott Station
Buffalo, New York 14205

Published in Canada in 2004 by
Firefly Books Ltd.
66 Leek Crescent
Richmond Hill, Ontario L4B 1H1

Printed and bound in Portugal

Executive Editor: Lisa Dyer
Design: Zoë Dissell
Copy Editors: Jonathan Hilton and
 Lara Maiklem
Production Controller: Lisa Moore

Cover photographs by Tom Ang

erotic
home photography

HOW TO TAKE YOUR OWN NUDE PORTRAITS

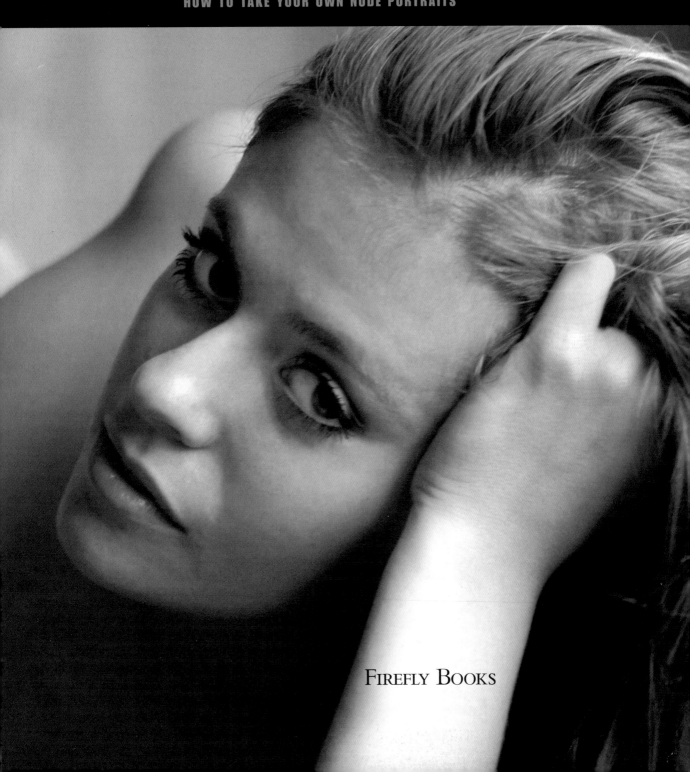

FIREFLY BOOKS

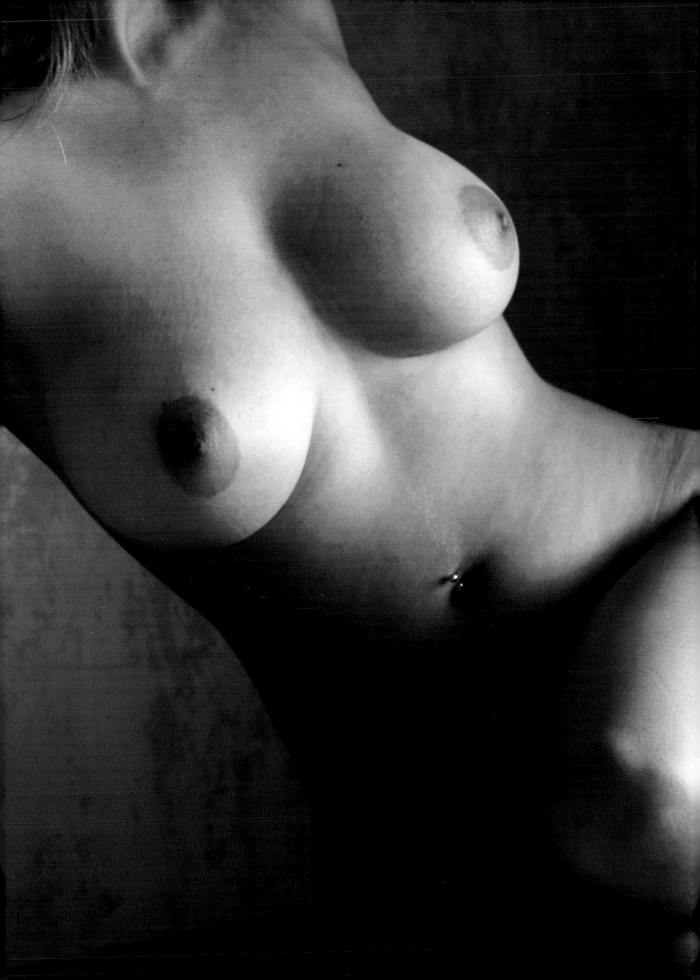

contents

introduction

A commission to photograph the main images for a new edition of the classic *The Joy of Sex* led to this book. The opportunity gave my wife, Wendy, and me our first professional experience of photographing nude figures, and the job also vitally depended on the use of digital photography. Due to a last-minute decision to change the photography in the book (all of which had been shot and designed), our first day in the studio was actually the day the finished files of the book were scheduled to be at the printer. Enter the digital camera to the rescue. As I photographed the models, the art directors were making their selections and giving me feedback nearly in real time – in other words, almost as I was shooting. By the time I was coiling up the cables for the lights, the art directors had finalized their selection. Thanks to digital-camera technology, we slipped just one day behind the original schedule.

It was a stunning demonstration of the power, convenience and efficiency of digital photography. It also introduced me to another kind of photography – one that celebrated the human form. I have always been drawn to the beautiful, and I love photography for its ability to commune with beauty as well as providing a means of sharing it.

This book is for couples who want to share their joy in one another through photography. It is not a book about nude photography or the "art" of it, as that is a more impartial, arguably more objective, approach. Nude photography keeps art at the forefront, with the emphasis on "photography," while erotic portraiture is unashamedly about the erotic. In this latter approach, the erotic is an element – if not indeed the quintessence – of the beauty of a person. And the erotic can be expressed in many ways, all of which portray a person's varied sides and forms.

This is what we will be exploring together in this book. I use "we" because this book was written by a couple for couples – most of the text is mine but Wendy, my wife and partner, has added her own observations, helping to make the point of view a well-rounded one.

Taking nude photographs of a loved one can bring out new dimensions in and add depth to the experience of your relationship – if only because, at times, it will be testing your trust in each other and challenging your inhibitions. But it can also boost self-confidence and pride in yourself. So go now: expose yourself, and trip that shutter.

TA and WA

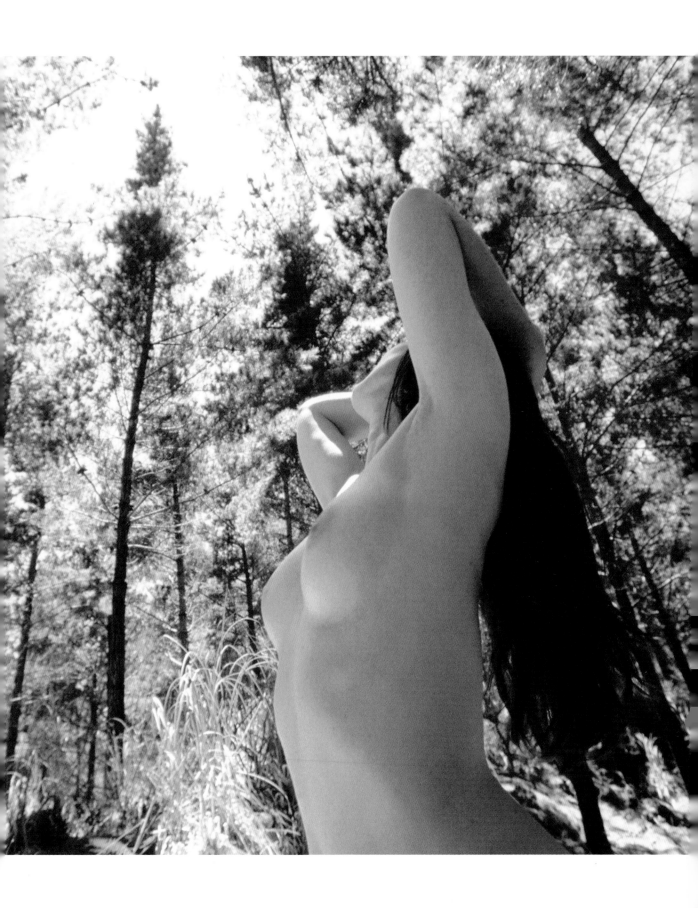

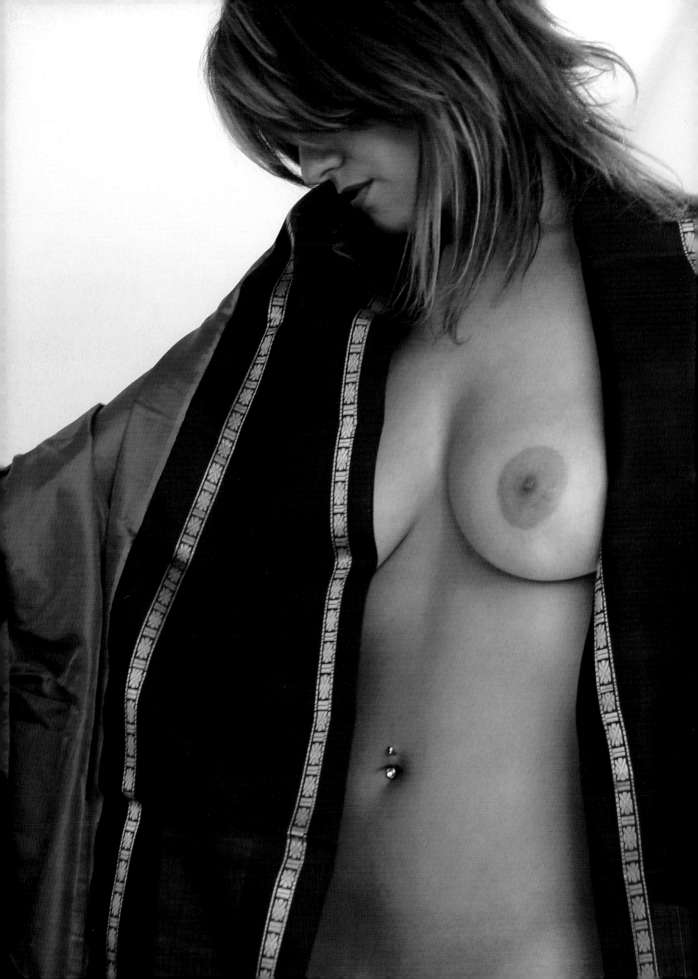

1

background

The love affair between photography and the human body has a rich and varied history. However, the two did not hit it off from the beginning. In their early days photographic recording processes were slow and incapable of capturing anything that moved, or just fidgeted too much. The insensitivity of photographic plates, and later film, necessitated a great deal of light, big lenses and long exposure times. The slightest movement would show up as a blur, a defect of the perfection that was sought. From the beginning, then, the relationship had its tensions. A normally live, moving, breathing form had to hold its breath, had to suspend its normal vitality before it could be recorded on film. And it was only after enduring the labor-intensive procedures of processing, printing and further processing that the image thus recorded could at last be celebrated and enjoyed.

Nonetheless, as primitive as it was by today's standards, the resulting image seemed magical, and everybody agreed that all the trouble was worth the effort. As soon as photographic technology evolved and where exposure times were brief enough so that holding your breath to the point of near suffocation was unnecessary, and as soon as using film did not require a degree in chemistry, then models happily took their clothes off for the eager lens. The camera and the nude human form commenced a productive and rewarding partnership – one that is still going strong today.

If you want inspiration, I'd say the finest place to look for it is in the beautiful tribute created by American photographer Alfred Stieglitz (1864–1946) in honor of his love, the painter Georgia O'Keeffe. Sensitive and sensual, adoring and often erotic, Stieglitz's series of portraits of O'Keeffe are a visual poem of love. The pictures are a "must-examine-closely" for anyone's visual education. Another inspirational group of photographs are those of American photographer Edward Weston (1886–1958), featuring his many lovers. While their technical perfection may intimidate the average photographer, the sensuality of tone and line is without doubt driven by erotic feeling – and that is something anyone can share.

As photography developed, so it reached further into dark, closed places, and its language also grew darker. From the narrow range defined by the celebratory, photography began to explore the entire sexual agenda, including the hidden items. At the same time, the relationship between the photographer and erotic subject spanned a wider range – from the collaborative, in which it is clear that lovers are working together – to the exploitative and dominating, in which the photographer is evidently in command of a subservient subject, molding the model to his or her desires as if she (the models were invariably female) were made of clay. So we have the naughty nude postcard that purports to be harmless fun, but may be criticized in the same light as pornography – both potentially being expressions of human abuse.

One possible example of the exploitative relationship between photographer and subject can

be seen in the book *Trouble and Strife* by British photographer David Bailey (1938–). The "trouble and strife" (cockney rhyming slang for "wife") referred to in the title, the model Marie Helvin, was allegedly surprised to find Bailey's pictures of her published in book form – apparently she had thought the shoots done with her husband were only for fun. By the time of publication, however, he was the ex.

Borderlands

This book is no place to try to define the border – the fine line or wide muddy expanse, depending on your views – between a celebration of the beauty of the unclothed human form and the pornographic depiction of naked sexuality. After all, both use the same visual language – form, light, bare skin, erogenous zones – to describe the body and photographic process. But each approach uses it in different ways.

The aim of this book is to produce private erotic portraiture, meaning the process of creating images of a lover that express the photographer's sexual feelings for their loved one. Erotic portraiture is, therefore, essentially a private thing. It is to be enjoyed, shared and explored between two people who intimately know and understand each other. Such images are not intended to arouse sexual feelings and desire in others. However, once made public, such images lose the support of the closely shared knowledge that enables original intentions to be understood. By making an image public, you take your hands away from the controls. Then, of course, viewers (that is, strangers) will respond to the images how they will – one may extract a universality (beauty, luscious light and so on) from the photograph, somebody else may respond sexually as it triggers a memory of a past lover, while another will criticize a loose flab of skin or other bodily imperfections. But none of these

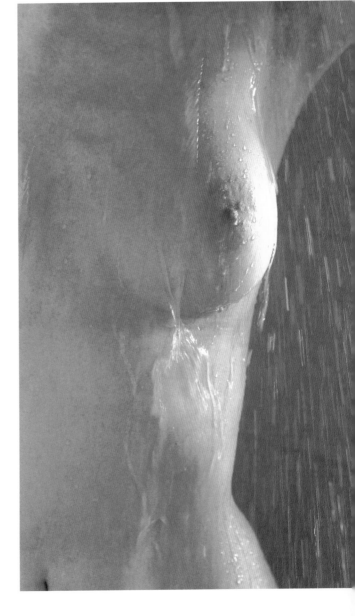

above Even the most everyday situations and rituals – such as taking a shower – can give you pictures of your loved one that celebrate her, or his, essential human beauty.

reactions was the express intention; none is what was originally sought. If love, sex, nudity and intimacy are essentially private in nature, then so is erotic photography in its portrayal and celebration

The subject/photographer relationship

Does using the terms "photographer" and "model" put one person in a weaker, more subservient position to the other? It is not possible to avoid this entirely, any more than it is possible to avoid always having one partner lying above the other during lovemaking, though physical positions need not be metaphors for the dynamics of a relationship. The real point is that you should both be equally enthusiastic about taking part in the photographic session. It is natural to have some doubts and concerns – perhaps about how it will affect your relationship or because you are anxious about how you will look (after all, you're creating a record that could become permanent or be spread around the world in an instant). What you really need to do is discuss your feelings and share your doubts.

below If one of you is nervous about formal posing, you can agree to "sneaky" snaps – if only to prove that your bottom is not too large or belly too obvious. The more you see yourself in pictures, the more relaxed you will be in front of a lens.

And why not share the photography? Of course, it is usually the man who wants to take the pictures because he says, more often than not, he wants to enjoy his lover's beauty. But women enjoy men's bodies, too, so neither of you should be shy about wanting your time behind the lens.

Age is no barrier

Another barrier to erotic photography, perhaps the most potent, is the fear of age. Surrounded and bombarded as we are by peerless beauties in film, advertising and sports, the rest of us wish reality was a funhouse mirror that made us look lithe, flat-bellied, well-muscled and attractive. And, above all, the beautiful are all young, almost as if part of their attractiveness is the promise of the long life still ahead of them. With all this pressure it is natural to be intimidated if you feel you're over the hill.

But the truth is that beauty, surpassing beauty, can be found in older bodies as well as in young ones. It is different for sure – it has a different pace and calls for a different approach. After all, your methods change depending on whether you are photographing tiny flowers or towering trees.

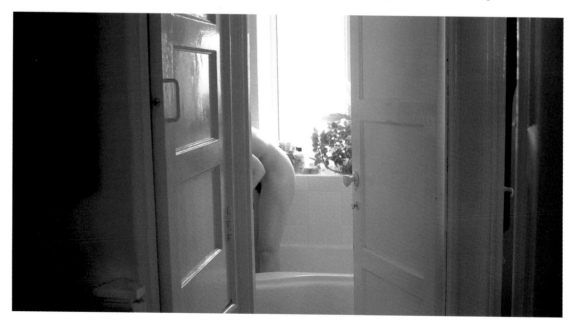

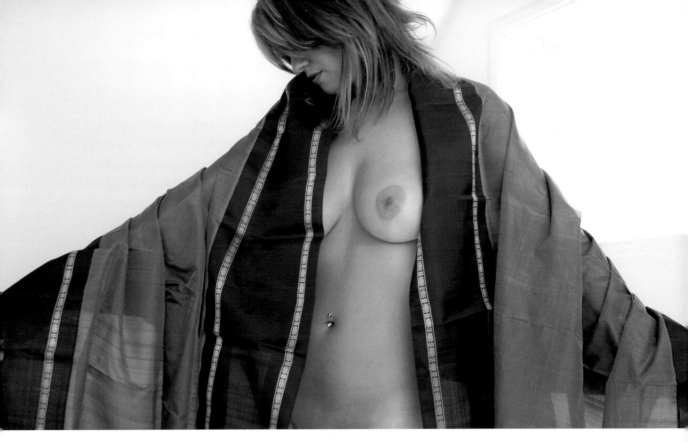

And do remember that the pictures you make are for your eyes only, for you to enjoy and to help you remember a loved one. What sums up the erotic in your partner – the twinkle of her eye, his still-strong grace as he leans on a spade – is for you or the two of you alone to enjoy. Capture that and truly you capture a moment of beauty for ever. Make no mistake, shaking off years of media indoctrination is no easy task, but to do so is more than a little triumph.

above If you don't want to show the most private parts of your body, then don't: simply crop the image. With digital photography you can change the original file, and in this way what you don't want to be seen can never, ever be seen.

right How old is the model under the netting? And would it matter if you knew or if you could work it out? In fact, the model is a young 40-plus. You can shoot in order to flatter and disguise, or you can simply respond to the beauty you see and do your best to have the image reflect your vision.

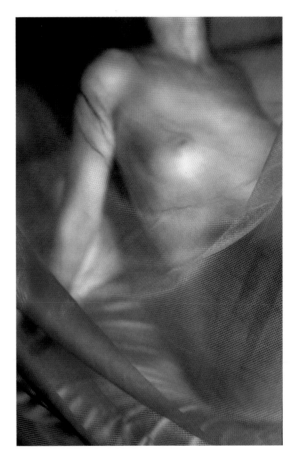

Legal concerns

The basics of relationships translated to the photographic medium remain largely the same as they ever were. At best, they are founded on mutual trust and respect, powered by love and admiration. They express themselves in ways that are personal and specific to the people involved. However, this is not a perfect world. Not everyone is as decent as the photographer who one day woke up to the fact that the nudes he'd shot years back of a young Italian model were now pictures of a pop-star called Madonna. He tracked her down, with difficulty, in order to ask her permission to publish his work.

To insist on signing agreements before you even lay a finger on the shutter button may seem too formal, unloving and damaging to a relationship through its implied lack of trust. But, as one lawyer acidly remarked about prenuptial agreements: if a wealthy client had *not* signed one, he should see a psychiatrist, not a lawyer. If there's a problem about

signing a document that's fair-worded to protect both parties, then embarking on this enterprise may bring risk to your relationship. But it is better to find out now rather than later, in the courtroom.

Memorandum of agreement

Above is a suggested "contract" for a simple agreement that you could modify for your own use and circumstances. Make two copies that both of you sign, and keep one copy each. It is best to obtain legal advice if you are at all in doubt, since a certain form of words or formalities, such as signatures of independent witnesses, may be required in your country to ensure that the agreement is legal and binding.

right Even though the person to whom these legs belong is not recognizable, if they are your legs, you may still care about who is in possession of the image. And who is to say just how much needs to be visible before an image is identifiable? To be on the safe side, be specific: no images can be used without permission.

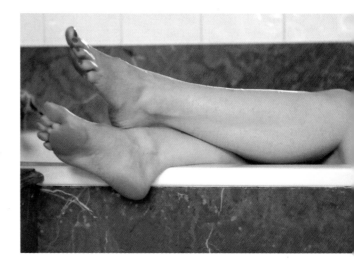

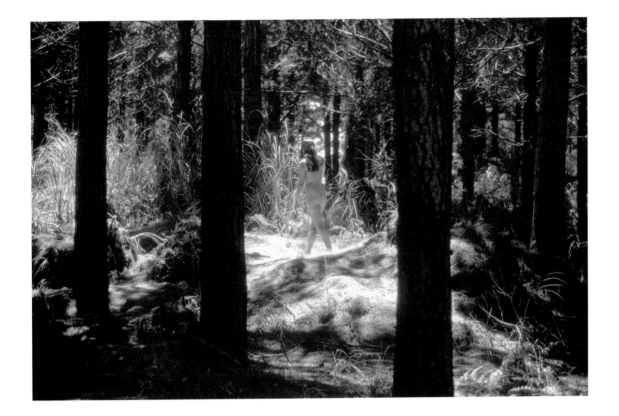

Forbidden fruits

Other legal issues are not so straightforward as they involve other people and, indeed, the law of the land. If you would like to conduct a photo session in the open air, for example, then be aware of potential pitfalls. In many countries, public nudity is a criminal offense that could result in severe punishment. And even if that desert south of Marrakech looks totally deserted, it usually takes no time for locals to sense your presence and wander over to see what you're up to. Bear in mind that it's their country, their backyard. It could be that they are checking you out, not from any prurient interest but because they are simply concerned that you may be causing some harm. If you are in any doubt, ask the local guides. Better still, research the question beforehand – perhaps at the embassy of the country you intend to visit – before traveling.

Take exceedingly great care if your partner appears to be particularly young, especially if he

above Whose land are you working on and could it be identified from your picture? Most people are reasonable, but in an increasingly litigious world, it is wise to be aware of the dangers you run.

or she appears to be younger than the local age of consent. You may encounter problems with laboratory technicians who could be instructed to report to the police any revealing pictures that might, even possibly, be of minors. That is a problem if you take images to any film-processing laboratory, but it is also a danger area should you take a photographic CD to a laboratory for printouts.

Problems could also arise when shooting in other locations – what may seem to be public land or spaces such as open fields, estates and town squares often belong to someone and are actually private. You have access to them on the assumption that you obey the rules – one of which may forbid nudity. If you breach any of those rules,

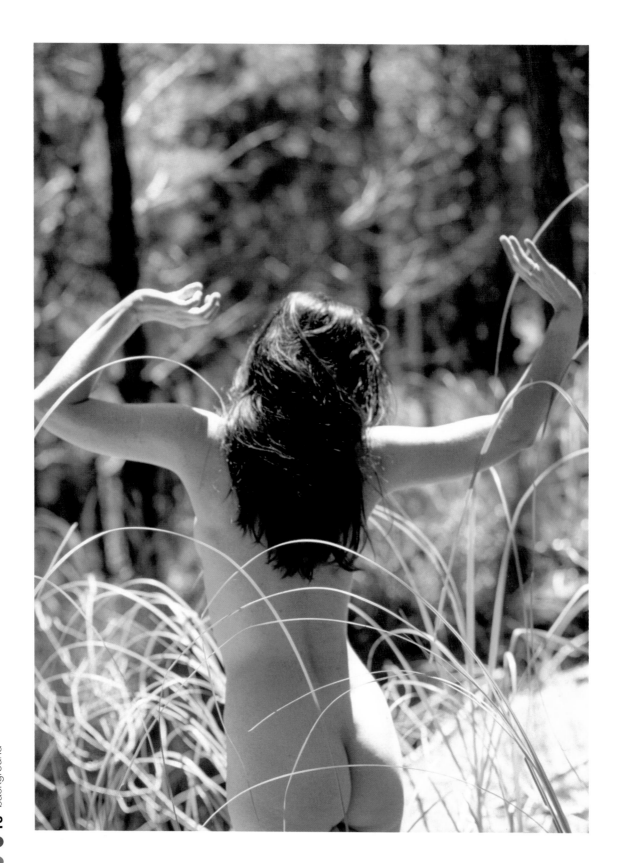

you could run afoul of the law. By the same token, photography in elevators, offices, hotel corridors or secluded corners of shopping malls could also land you in trouble. Keep on the safe, if unadventurous, side and always ask permission first. You never know, you could be pleasantly surprised. However, if it looks like you are working professionally – perhaps using an expensive lighting outfit or a flashy camera mounted on a big tripod – you could be charged for the privilege. Too often it's the photographer who wants to try risqué tricks, but it's the model who is actually taking the risks. So, if you don't want to do it, say "no."

All these caveats present a strong argument to work in the privacy and safety of your own home or where you can be sure to be left alone.

Breaking the mold

It is no exaggeration to say that digital technology has wholly recast how people approach amateur photography. We will look in later chapters at how we can all exploit the numerous advantages offered by the digital medium. At the same time, those who are happier with their traditional film-based cameras do not need to feel left out: the basic principles of photography remain largely unchanged.

The three pillars of digital photography are self-containment, cost and convenience. Self-containment means that if you have your own computer and printer, you can conduct the entire

right A room being redecorated and a dining table: what could be simpler? But they provide ideal backgrounds for nude photography.

opposite Lacking the usual clues to age (this is a well-toned, exercised body) and size, an over-zealous laboratory technician may feel impelled to report this image to the authorities.

process yourself. In fact, you don't even need a computer: many modern printers will now print directly from the camera (see pages 119 and 123). In this way, the image can remain truly private. The cost of starting up in digital photography might seem quite high, but the running costs compensate for this initial outlay by being extremely low. Gone are all the film and processing costs (though you do need to buy memory cards). And of the three "pillars," the greatest advantage of all is the sheer convenience of going digital. You can, for example, see immediately what the image looks like, you can take as many shots as you like, delete them at once or at your leisure, or keep them all. And you can show each other the results immediately and discuss them as you go. If you don't like a shot, then just insist on having it deleted there and then. This gives some power back to the person being photographed and that is important. What luxury!

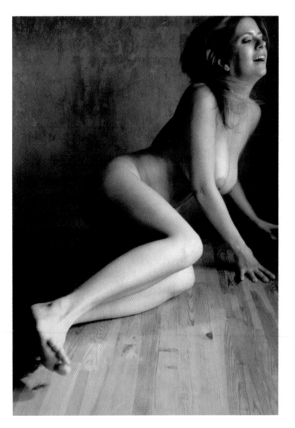

2

setting
the scene

So you have both discussed the idea and are keen to start photography. By all means strike while both of you are hot and eager – just go ahead to your favorite place, strip off and start clicking away. A moment's thinking might slow you down, however. Does the idea of a little nude photography in an outdoor location drive you wild, or do you long to stretch out in front of a fireplace? Are you looking pale-skinned after a long winter? Or is that stomach just a tad more obvious than usual, thanks to a gastronomically indulgent vacation? And maybe you could improve the lighting in the room, not forgetting to do something about that bedspread or those curtains. A little planning combined with some imagination and props can make the difference between a memorable finished result and a lackluster one.

Planning can be fun

Professionals in any business will tell you that five minutes' solid planning and careful thinking can save days of grief and unnecessary trouble. Besides, it shows that you are serious and you care. And it need not take the fun out of the activity, either. On the contrary, provided you both take each other's suggestions seriously, planning is something that can bring you closer together.

So what are your partner's fantasies? If she wants to be naked under furs or if he wants to wear cowboy boots (and nothing else), you will have a laugh as you let your ideas run riot and explore different themes. Then you can scour the shops and your own wardrobe together, haunting flea markets for inexpensive props, raiding charity stores for old clothes, or treating yourself to that pair of shoes that make you walk tall. The true but hidden reason for your purchases adds spice to an already fun task.

The following tips may help you become better prepared for your shoot so that you can spend more time working with the camera, rather than searching for items to create the setting or set the theme you want.

- **Timing** Choose a time when you will both be relaxed, free of worries and without any commitments for the next few hours. A day on the weekend is ideal.

- **Forward thinking** Avoid wearing tight clothes and underwear as these will leave marks on the skin: it can take more than an hour for signs of a tight bra or panties to disappear.

- **Music while you work** Music that you both like can help generate the right atmosphere for a sexy photo session – make a selection of CDs or MP3s in advance so you don't interrupt the flow.

- **Heaven scent** Another way to induce relaxation – with or without music – is via aromas. Burn perfumed candles or incense, or heat essential oils, such as ylang-ylang, rose or lavender. However, candles will not show up well in the images if they are the only source of light. Working by candlelight is for experts and very capable cameras.

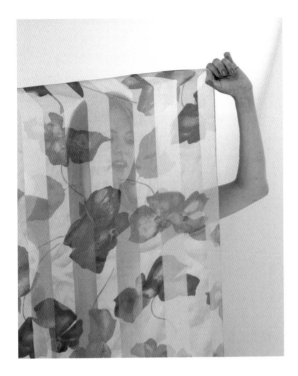

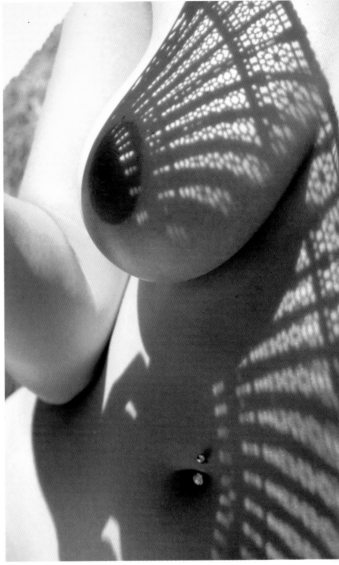

The prop shop

Dive into the bottom of that closet of yours – you know, it's the one you haven't tidied up for ages – and you're sure to find props for your photography. Old feather boas, discarded scarves and tapestries, that ridiculous hat from last summer's high-school reunion ball, the Catwoman fancy dress costume you made – the less tidied up that closet, the better the treasures it's likely to contain.

And remember that with your clothes off, or nearly off, familiar items can change their significance and connotation. A large hat for a formal wedding becomes an item that you can have fun with, enabling you to play with visual meaning when partnered with the nude form. A party dress half undone provides the classic image in which something once concealing now entices and seduces. The open dress becomes the focus that invites the erotic gaze. For men, try working with the jeans' top half undone or a wet t-shirt stretched tight over bulging pecs or biceps, or use sports equipment and hats as props.

above You don't have to use the prop or feature it explicitly. A Chinese fan seemed fun to play with (and the model appreciated its proper function on the hot day) but what caught our eyes was the intricate shadow that it threw. The shadow then became the prop, almost pushing the subject aside.

above left At first the scarf seemed too strongly patterned, but the sheer stripes allowed the body to show through, resulting in an image that works better photographically than it looked in reality.

VERSATILE PROPS

- Scarves – especially with long, see-through panels or chiffon types
- Hats – any size or shape
- Old dresses and slips
- Stockings
- Oversized shirts
- Dressing gowns, robes and kimonos
- Textile remnants and throw rugs
- Ostrich or peacock feathers and boas
- Flowers

One of the most important considerations when using props is that they need to be materials you can play with – be inventive with and uninhibited about. When you go shopping, you may find that virtually anything you lay your eyes on could be put to good use. Even in the supermarket think of what you can do with fruits, pasta, sauces, certain vegetables or cakes.

Of course the antique shop is a gold mine for props – old pictures, lampshades, glassware and mirrors. Even one piece can be enough to create a unique room setting. Just don't needlessly spend a fortune on items that you cannot or will not use again, and keep in mind that many items are good for only one or two shots. You may find that clothing is far more versatile, and you can get good value out of such apparel as jackets, robes and kimonos, shawls and scarves, or stockings.

below Even something as mundane as a towel can act as an effective prop – literally, it can help your model feel more relaxed as it provides some cover while he or she becomes accustomed to the idea of baring all for the camera.

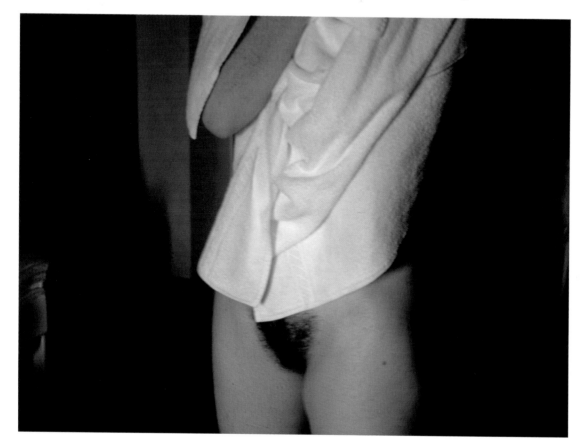

Researching for inspiration

Sourcing ideas for your photography does not mean hours spent in a musty library. Research is more about looking at material in a new way, one that is directed toward a certain goal. Even some junk-mail clothing flyers or catalogs could give you ideas for posing and the use of props.

Don't be afraid to copy or apply ideas you see in magazines or flyers. Rather than stealing anything, you are simply learning from the real masters. Pictures in magazines can take on new values – the fashion shoot in a doorway, for

above New places always mean new possibilities – you don't have to research the right location so much as keep an open mind. Here, the netting and carved bed in this Zanzibar hotel room were the inspirations for the photograph.

example, no longer means haute couture. It can mean something entirely different if you take a photography tip from it, such as how, if you place your model in a doorway, he or she can be lit from in front and behind while being framed by the door with its rough wooden textures.

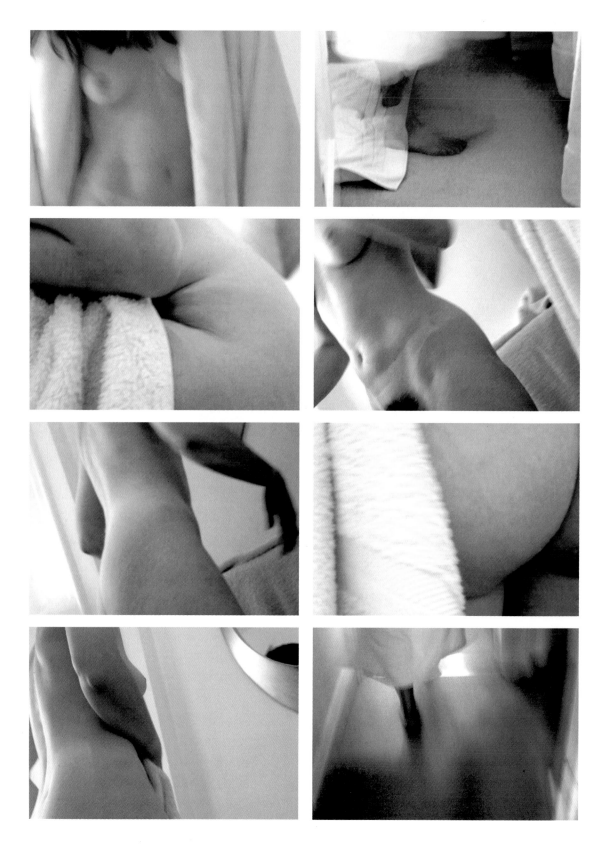

To ensure that you do take your lessons from people who really know what they are doing, look through the best-quality fashion or women's or men's magazines. It is unlikely, however, that you will learn much from photography magazines specializing in glamor photography or websites with the same emphasis – unless you want to see what not to do. Above all, trust your own good taste and that of your model. If your model feels uncomfortable, you can be sure that the resulting image will be neither true to the real trust in your relationship nor will it rekindle warm feelings when you look at it. First reactions count in this arena.

The most potent of all sources is, perhaps, the movies. Not only do the movies have a rich tradition of erotic scenes, and not only can you have a good deal of fun doing your "research," but you are literally at the shoulder of the greatest camera and lighting technicians on the planet. By observing the lighting in a film you can see, for example, how a body can be beautifully lit even though the room is dark – the light comes from an adjoining room. Learn, too, how concentrating the gaze on just a small part of the body can reveal the whole steamy atmosphere. Finally art, too, can be a great source of inspiration: a trip to a gallery or exhibition is sure to reward you with ideas.

Let the camera break you in

One of the great releasers of inhibition is simply to press the camera's shutter button … and then press it again. If you are using a digital camera for your photography then you obviously don't have to

opposite Aim for high art if you wish, but don't expect it: let the camera do the work and you and your model can make the selection together later. These pictures were shot within a space of a few minutes, chasing the poor model playfully all over the house while she tried to jump in the tub.

worry about how much expensive film you are running through the camera. Nor do you have to wait any time to see the results of your efforts.

To warm up, simply frame the shot and press the shutter button. It doesn't matter that the picture is not a great work of art (though it may be). It doesn't matter if it is ill-framed, out of focus and the pose is not especially flattering. Just press the shutter again. And again. After a while, you fall into a rhythm.

There is a scene in the film *The Good, the Bad and the Ugly* in which the "Good" (Clint Eastwood) hears far-off gunfire. From the rhythm of the shots he realizes it's one of the baddies – it's the sound of an expert at work. Similarly, watch an expert photographer at work and you'll hear a rhythm: click, click-click; change position and focus, click-click, click-click; change position, click-click-click. It's important to keep firing as it gives your model confidence. Hearing that shutter makes a model feel desirable and appreciated; it's like a rippling murmur of applause. Silence from the camera implies, if only subconsciously, disapproval. Because you don't have to worry about film costs, you can work like this, and it can be so liberating … and artistically rewarding.

PLAYBACK ON TELEVISION
Many digital cameras will display images on an ordinary domestic television. All you have to do is connect the camera to the back of the TV using the cables supplied with the digital camera – usually these include a small plug that fits the camera and two separate plugs at the other end for the television.

Once you are connected, enter the replay mode in the camera, turn the TV on and your images will appear on the screen. Simple as that!

Preparing a room

When considering an at-home location, why not take the opportunity to improve a room in your house? Perhaps you've been meaning to repaint the guest bedroom anyway, and you've been thinking it was time to renew the drapes in the living room. Perhaps a luxurious fur rug is an indulgence you now feel you can afford – and what a prop it would make. If carried through with care, this type of room makeover could be ideal for a photo session as well as being a valuable home improvement. The advantages just pile up.

Preparing the room can help you relax: it gets you involved and gives you some control. But even the smallest room can offer enough space for a shoot. The important aspects are to feel safe, comfortable (and warm) and secure in the space.

If you have any experience of photography you will know that lighting is the start and the end of it all. Unless you know what you are doing and can work with moody, subdued illumination, ensure that you have ample light in the room. Wall sconces pointed towards a low ceiling will create a soft, even lighting effect, while low-voltage halogen

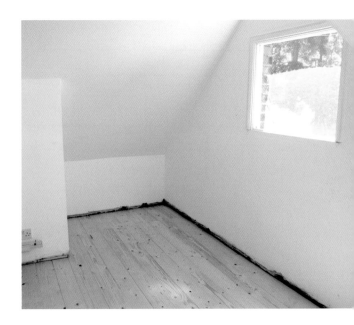

above Are you planning to decorate a room in your home? If so, it will present an ideal opportunity to create a wide range of different photo effects as work progresses. You can photograph, for example, while the walls are stripped, giving the background that chic distressed look. Or, for a minimalist look, conduct some shoots after you've finished painting but while the room is still empty and uncluttered.

HOME FINISHING FOR PHOTOGRAPHY

- Subtle contrasts are best. White sheets, cream covers and light yellow walls blend well with each other and contrast attractively with body tones without overpowering them. This type of setting works well for either color or black-and-white photography.
- Avoid strong differences in color or tone in your setting. For example, a purple drape against a pale blue wall may look fashionable in real life, but in a photograph the purple may look nearly black and the pale blue comes out as white. The result is an image displaying excessive contrast.
- Fine patterns such as small polka dots, pinstripes or small floral designs can work well with body tones and can help to maintain an appropriate scale and proportion – so, too, will fine textures such as those of raw silk, slubbed cotton and cords.
- Avoid strongly geometrical and large, regular patterns. Large, irregular designs, however, such as floral patterns, can provide a counterpoint to subtle body shapes but must be used sparingly. If they appear too often in pictures the design can become dominant and distracting.

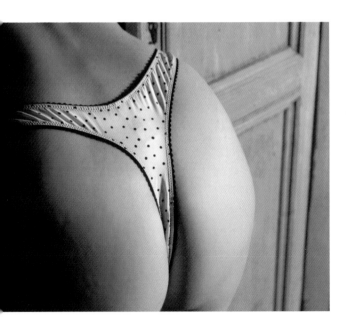

above Interesting images often revolve around how carefully you manage contrasts. Here, the contrasts are between the polka dots and the smooth skin, between the green door and warm skin tones, even between the geometric lines of the door and the sensual body curves.

lamps produce a much harder lighting scheme. Neither is correct or incorrect – it all depends on the mood you want to create.

The color of a room will affect the colors of your photographs, unless you plan to work in black and white. On one hand, if you have green walls, you can expect flesh tones to take on an unattractive hue, likewise with blue and purple walls. On the other hand, warm colors, such as reds or pinks, and yellows and oranges, tend to flatter most skin tones.

Similarly take note of any intrusive features in a room, such as large paintings, utility ducting on the walls, overhead beams, fixtures and architectural features, and consider the effect they will have in the background of your pictures. You don't have to remove these items or repaint strongly colored

walls – if you want a plain background, just drape plain white or cream sheets over the offending items and walls. However, don't discount the possibility of using a painting or mirror in your photographic compositions, or having straight lines contrast with lovely body curves.

Sprucing yourself up

A common reason for a partner not wishing to be photographed is that they do not like the way they look – too fat, too skinny, a large belly or fat thighs are just some of the most common complaints people have about themselves. Either accept yourself as the way you are or determine to do something about your "problem areas."

You may not need to go so far as a makeover – after all, it's the real "you" that you want to see in the photographs. But anyway, it's a great excuse to do all the things for yourself that you always wanted to but were too inhibited to ask for.

So you would like to lose some weight? If you are planning your shoot a month or two in advance, you could give yourself three or four weeks to go on a light detox diet, eat normally but add extra vegetables and fruit while cutting out those hip-increasing cakes, chips and deep-fried treats. You will feel healthier, more energetic and ready for romping in front of the camera.

You could also try some physical exercise to improve your body shape. Come on, are ten sit-ups a day for the next month really too demanding? Simple, achievable regimes are guaranteed to do wonders for your preparedness to show yourself to the camera, assuming your eating is also under control. There are hundreds of books on exercise for slimming, but a common-sense suggestion is to simply try to incorporate light exercise into your daily routine, such as a program of sit-ups, push-ups and an aerobic activity, such as running or cycling.

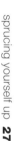

Cosmetic help

Consider cosmetic solutions that will help you look your best in front of the camera. As a model, you can be as natural or cosmetically enhanced as you like, however you should take the time to become well-groomed. Small details such as dirty fingernails or stubble from hair growth tend to be magnified on camera, and even the least vain people can become self-conscious about their "flaws." If you already have an ongoing exercise and nutritional regime, you can round it off with a well-deserved pampering – such as a facial, haircut, manicure and pedicure. When you feel great about yourself, you will feel great about being photographed.

One way to feel your best is to apply a little makeup. Whether you are a male or female, this is a matter of personal taste, but makeup can also be used to create some stunning visual effects. Also, no one has perfect skin, so take your time to disguise features you don't want seen in the picture. A camouflaging concealer can soften the appearance of scars or blemishes. Simply

reducing the visibility of a spot or scar may be enough for it to disappear in the digital image. Also, oiling the skin shows off muscle definition, or doing a little exercise beforehand can give you a glow. If you are going to be lying down or holding your body in a particular position, be aware that the skin may become reddened. A change of position or shaking the affected limb often helps the skin tone to settle down to its normal color.

If you feel you are a little too pale, you can try tanning lotions. The best are spray-on versions applied by experts, who will simulate the natural gradients of a real tan.

below The hardest part of yourself to prepare may be your skin. But don't worry, image manipulation (see pages 84–113) can deal with the worst scars, bruises and blemishes – just ask the celebrities who have technicians pore over their images, removing every speck. Even this model, with immaculately lovely skin, had a couple of tiny moles removed for this photo, shot in unforgiving direct light.

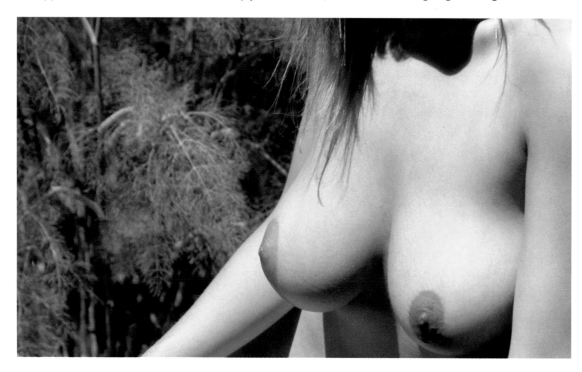

above The usual digital trickery to deal with spots and marks on the skin is to clone them away but you also have other options. Here a slightly shaky shot is digitally stirred a little more. What the viewer does not see, they do not know about.

Posing

You can also make the most of yourself when posing for a shot – and that is not just a matter of holding that tummy in. A little muscle tension when you stretch out your arm, straightening yourself out instead of slumping into a seat or simply holding your breath in can all do wonders for the shape and tone of your body. Another simple trick is to show the outside of any bend or curve in the body, as this will be stretched, while the other side may be folded and look less attractive.

LOOKING GOOD IN PHOTOS

- To avoid blinking, the photographer can give an instruction, such as "Look down and then look up at the camera," just before the photograph is taken. This way, the eyes are less likely to blink.
- To give the impression of thinner limbs, lift your arms away from your body and stretch your legs out in front of you.
- Long hair makes an excellent prop: you can drape it over yourself, play with it or hide behind it!
- Avoid smiling too much, and be sure not to force it; natural smiles always look best.
- Avoid "staginess" by moving into a pose, and not holding one pose for too long.

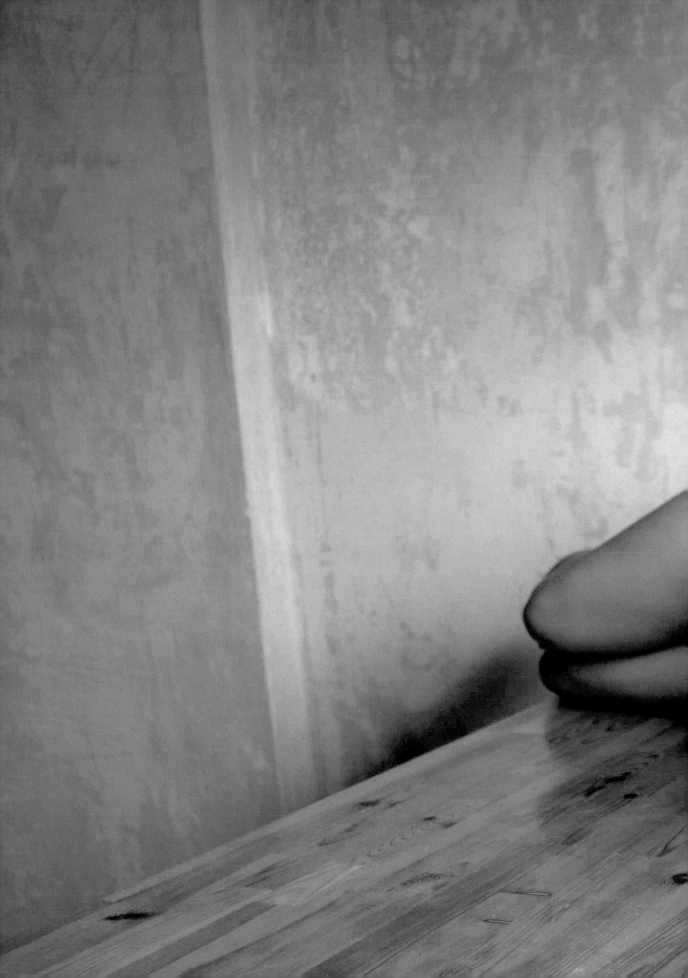

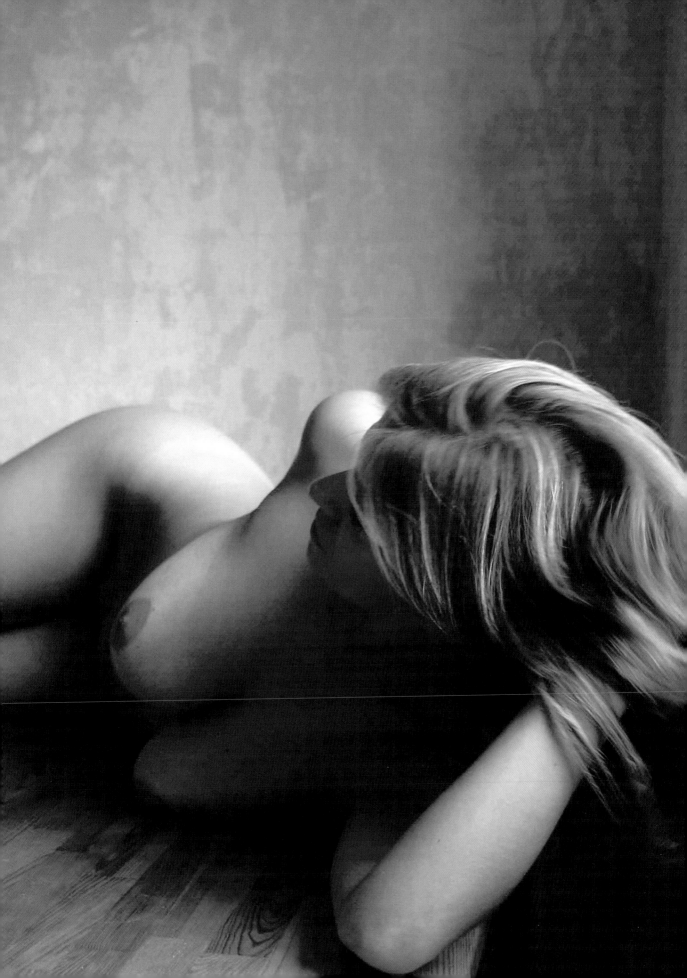

Setting the scene and the time

With our busy modern lifestyles, the time you can allocate for photographing each other is likely to be the time you can find to be together. Because it is high-value, a little planning is worthwhile. For most people, daylight hours available for photography are confined to weekends. Even so, think about the position of the room. Does it get morning light or is it bathed in light at sunset? Both of these are the best times for photography in terms of the quality of the natural illumination. The high light levels not only make it easier to see to shoot in, but they also provide modeling light – one that shows off shapes and textures and brings out colors.

But you should not neglect the times of day when the room is not quite so bright. These are occasions when you may want to emphasize subtle tones, soft colors and blurred contours. And the lower light levels also mean you can experiment more easily with subject movement during exposure, or use higher speed settings to create image textures.

opposite A rewarding time to take a photograph is when the light is constantly changing. Keep shooting the same pose in shifting light conditions so that you end up with shots varying from soft to hard light.

below In a corner that is free from clutter, your model will have a perfect space for posing. Here you can delight in the human form without any distractions or competition from other items.

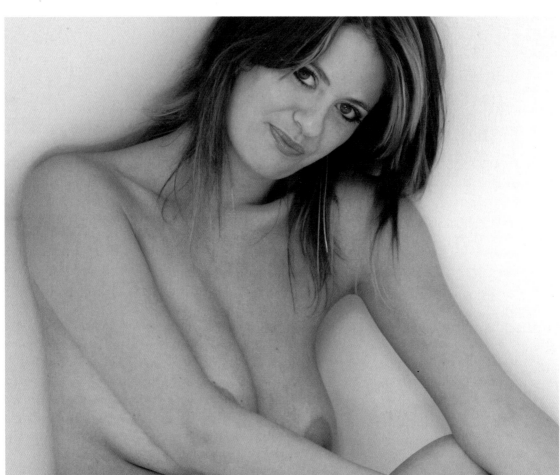

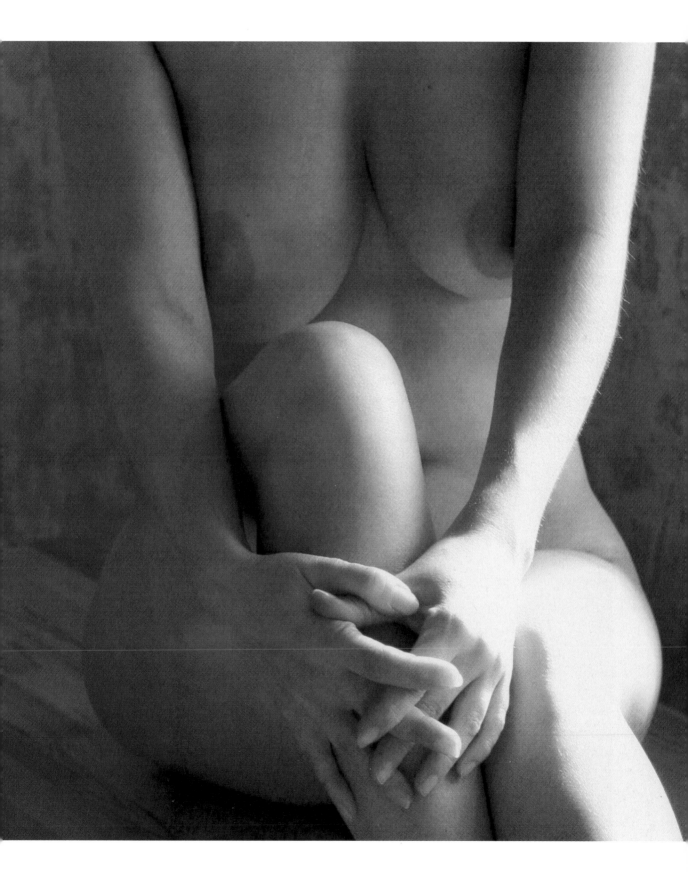

Birds of the forest

If you want to take pictures outside the home, it is best to do some careful planning first. A sun-dappled, peaceful forest glade, aloud with distant birdsong: what could be a more natural way to turn you and your partner on and send the imagination into overdrive? Before the clothes and the lens cap come off, however, observe a few precautions.

Few forests that you can gain access to will be totally uninhabited. And even if there are no people around, some of the animal residents may pose a danger, depending on which part of the world you are in. So before starting, have a good look around for the presence of all interested parties. At the same time you can also judge camera angles, lighting conditions and suitable places to pose.

below Wooded areas may be one of your favorite places to work. However, although you can be well concealed, watchers can also be hidden there.

Choosing locations Remote and far off the beaten track is better than just out of sight of a busy campsite, obviously. Go for locations where you can see people coming from a long way off – for example, the far end of a long beach or at the top of hill. But don't trespass on private land and don't climb fences to reach your location. Check the ground very carefully for biting ants or stinging or barbed plants before you expose bare skin to it. Above all,

INTERNATIONAL THOUGHTS
The advice on these pages is given with a major caveat: don't take risks in countries where nudity and revealing photography may be classed as criminal acts. In your own country you may be able to talk your way out of trouble with abject apologies – but attempting to do so in a foreign language is never a good idea.

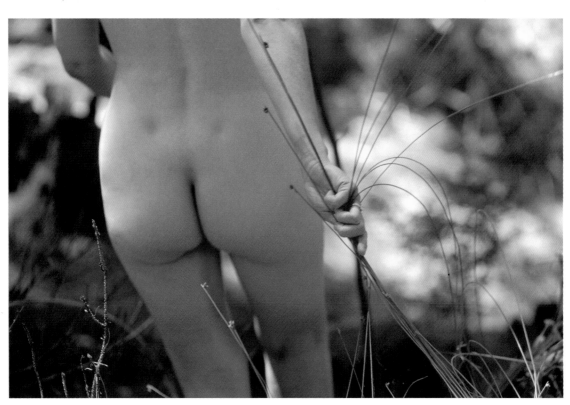

make sure the ground is sufficiently clean for you to use safely. And finally, don't forget to leave the location exactly as you found it.

Choose your moment Weekends and public holidays are the obvious times to avoid because of the extra danger of being observed, as are school holidays when children and their parents are more likely to be around midweek. Dawn usually sees very few people up and about, whereas sunsets can be busy, particularly near scenic spots and panoramic outlook points. Lunch to midafternoon are often quiet, especially midweek.

Work quickly Your model does not have be nude for very long. Use clothing that is easy to remove but not too obvious – a bathing robe, for example, is easy to take off but you will look suspicious to anybody passing by. It is better to use normal day clothes, such as an oversized shirt with loose

jogging pants, for example. Set the pose, check the lighting and camera settings, then disrobe. A few quick shots later and your model can be fully clothed once more, ready to find a new site or discuss new poses.

Consider the model Don't forget that when the weather is warm enough to take your clothes off, it is also warm enough for mosquitoes, ticks and flies to be prevalent. If biting or buzzing insects pose a problem, cover well with a nongreasy insect repellent. Make sure, however, that you choose a product you have used before, one that does not cause skin discoloration or allergic reaction.

below Working in the garden is convenient and can be private, provided you are not overlooked by neighbors. If space is limited it can be difficult to avoid a cluttered or busy background: try placing the model as far away from the flowers as possible.

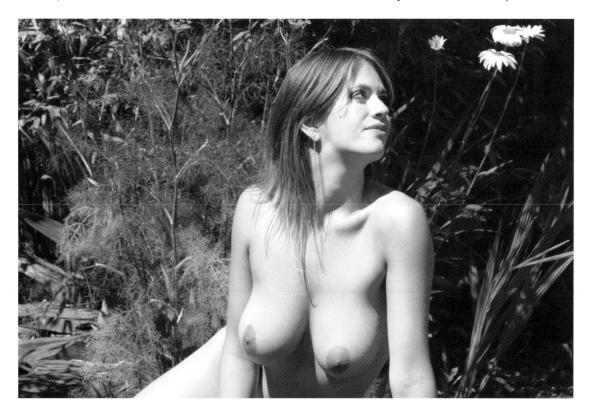

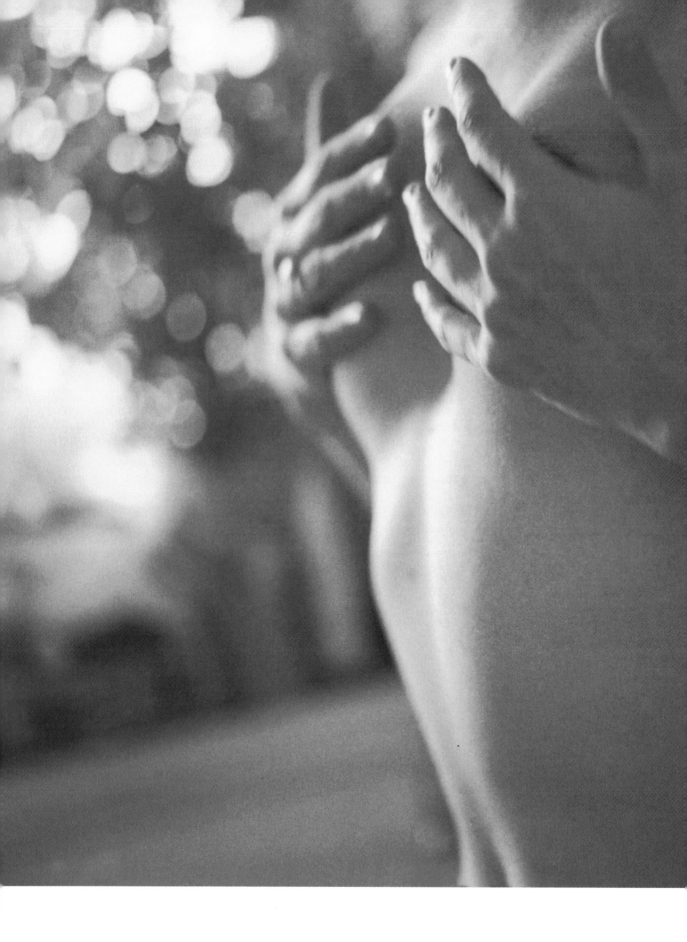

Shot lists

After all this talk of planning you'd be forgiven for wanting simply to get on with it. Sometimes you just want to be spontaneous, and if that approach suits you, then fine. Other people, however, find an extra bit of planning helps things go smoothly and boosts their confidence in the process. Even with planning, you may find that your ideas dry up after the first few excited minutes of inspiration and you don't know what to do next. That is natural – you are not a professional photographer.

In order to avoid an embarrassing hiatus in creativity, try making a list before the photo shoot commences of poses and the props you want to try, along the lines of the "bathroom" example shown below. Then if you do lose inspiration, you can refer to your list to help keep you going. The list is useful for the model, too, as it keeps two minds on the job. As you gain in both confidence and experience, you will need these supports less and less.

left This is one of our favorite shots: the simple action of applying moisturizing cream is shown in all its intimate warmth, unashamed of its inherent sexuality.

SHOOT LIST: BATHROOM
- Bathrobe on, partly off and fallen to feet.
- About to get into bath, leaning over testing the water and stepping in.
- In the bath: standing, leaning over to turn on the taps (faucet), kneeling and lying.
- Bath water: clear water (full, half-full), some bubbles, and lots of bubbles.
- Positions in bath: lying, sitting, curled up, leg over edge of bath, and arm over the edge of bath.
- Getting out: reaching for a towel, drying off, combing hair and applying lotion.

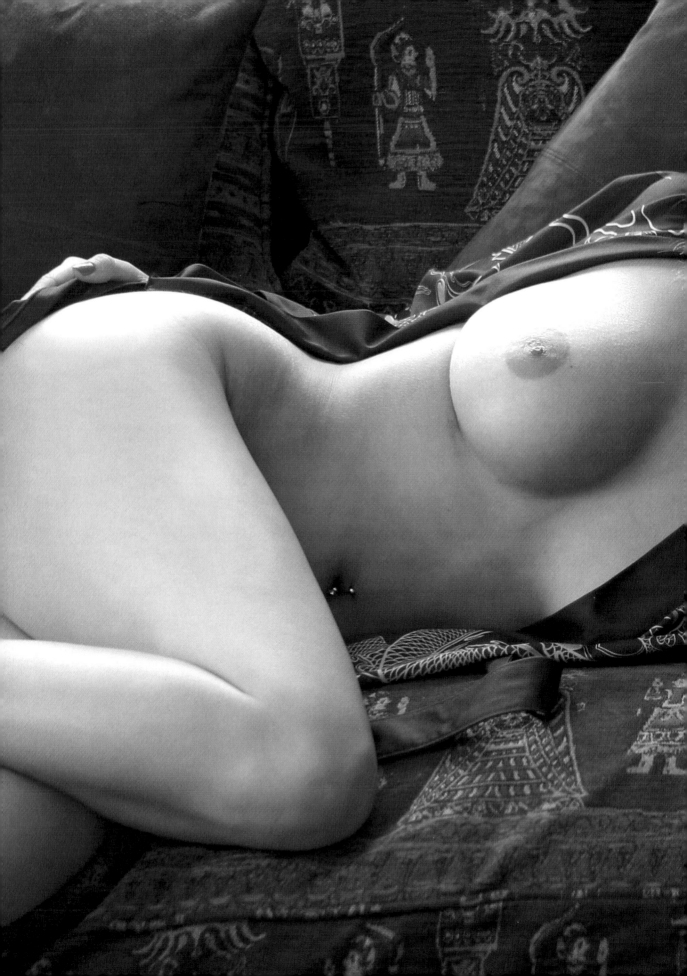

3
solo
pictures

The main thrust of your imagery will center around your perception of your partner's beauty – that person as an individual, a solo personality. In this chapter, we systematically explore the visual world of a single body. I always find it delightful, amazing, as well as humbling how much richness and variety can be found with just one person, fully explored, accepted, celebrated and appreciated. It is an amazing truth that the more you look, the more beauty you will find. But there are no certainties, except that the more effort you put into your work the greater the returns are likely to be. Great pictures do not walk uninvited into the camera. In the course of discussing different poses, this chapter will also touch on and advise on different camera techniques to achieve specific effects.

Working with the body

Let us assume you've prepared the photographic space and talked openly about what both of you want to achieve in the upcoming photo session (and, hopefully, enjoyed some laughs in anticipation of the togetherness you're about to enjoy). And you have also succeeded in that rare modern thing: found some time together. It's your first time and you are understandably nervous. Now what?

First of all, remember that marks on the skin from overtight underwear will take some time to fade. If marks on the skin from tight panties or bra lines are present when you take off your clothes, don't fret. Instead, use the time until they disappear to warm up and get used to the unfamiliar situation. You will learn from this that next time, the model should wear loose-fitting underclothes – or none at all if possible – so that you don't waste any precious photography time.

However, don't forget that the disrobing process itself can be a great photographic opportunity.

Giving instructions

It is almost an art in itself to give instructions to a model. Not only do you have to concentrate on

what you are doing, you also have to find the words to encourage and cajole while giving often quite bizarre instructions – tilt your head, lift your left elbow a little, turn your right shoulder toward me, and so on. All the while you have to remember that your right and left are the opposite for the model.

The key to working with models is to ensure that they move smoothly, steadily and slowly without tension or unnaturalness. And the best way to achieve this is to give instructions in a calm, steady voice, as this is also the best way to reassure your model. Give loads of encouragement and if the pose still doesn't look great, remain measured and diplomatic. Remember that it is easy for somebody standing nude in front of a camera, already feeling physically and emotionally vulnerable, to be put off and discouraged. The best advice at this point is to forget the cinema icons of photographers shouting orders at their models as if they were controlling a

opposite Stay alert as your model works with props or as he or she gets ready for you – charming, intimate moments, not necessarily nude, can show themselves to you. All you have to do is keep your eye on your loved one.

herd of unruly goats. You won't get much behaving like that in real life … apart from a slap in the face.

With experience you will find yourself giving more specific and helpful instructions. "Lift up your arm," you say. But the model thinks, "Which arm?" and "How high?" So you learn to say, "Your left arm looks good there. Try lifting it past your head; elbow at the same angle."

You learn not to say "That's absolutely gorgeous, but just turn right around to face me." If it looked that gorgeous, then why completely change the pose? You were obviously speaking nonsense. So, instead, you learn to say "That's not quite there. Let's try turning around – steady now, bit by bit – to face me; keep your arms up." Instead of instructing, "Look at me," you learn to say, "Now, slowly turn your face towards me and keep your chin up." The steady, controlled movement means that it is easy for the model to stop at precisely the right point, or find it again if he or she misses it.

With experience you also learn that sometimes the best pictures come in between two poses you are working on. It's often this transition point, when the model is more relaxed and off-guard, that gives animation and lifts a picture away from the stagy shots in which the model looks like a stuffed museum exhibit – the types of poses that pass for "erotic glamour" in magazines.

There is a place for the strongly posed shot, as a small amount of tension, combined with poise, can create an intriguing mood. However, be aware that the difference between a silly-looking position and a strikingly effective one is very subtle. Working with dancers or actors can help you learn to recognize when this technique works and when it doesn't.

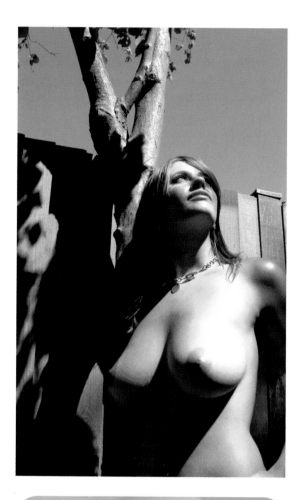

TO PLEASE OR NOT TO PLEASE?
Throughout the course of a photo session you might issue dozens of instructions. If you always say "please" with each utterance, the incessant repetition soon becomes irritating for everyone invited. But if you never say "please" it can alter the tone of the session for the worse. A good tip is to start off saying "please" with each instruction and then let it slip away as you both get into the flow. Then, if you want your model to hold a pose that is a little tiring, or it's getting toward the end of the session and fatigue might be setting in, it's best to reinstate it once more.

How close you can actually get depends more on what your camera can do than on any artistic notions you may have. If you are fascinated by the fine hairs on her thigh, if you love the bristles on his chin, get close enough to reveal the detail. You can always pull back to reveal the shapely legs or the handsome face.

Another factor is that small digital cameras are less intimidating when held up close to a body than the big lenses of larger cameras. Like it or not, subtle factors such as whether your personal space is invaded or merely entered into can have an effect on the pictures.

Close-up photo techniques

The majority of digital cameras offer close-up abilities far superior to those on autofocus compact film cameras. However, it is best to use a type of digital camera that gives you a magnified view of the subject from further away rather than one that has to be physically close up in order to produce a magnified view (the view from further back usually gives a more attractive perspective overall). Working close up also means that very little, apart from the exact plane being focused on, will be completely sharp. This area of reasonably sharp focus is called the "depth of field." This is a feature of all lens systems, no matter what camera you are using, and it is something you need to learn to work with.

Indeed, you can use limited depth of field to your advantage: keep just the crucial detail – a curvaceous upper lip, a nipple or a cascading lock of hair – nicely sharp while the rest of the image can be very soft.

above left By keeping all the elements in the picture lying in the same plane, facing the camera, even an extreme close-up photograph can render every element sharp and clearly defined.

Close up and abstract

Moving in close to the naked body with the camera is the easiest way to start your portrait photography. For one thing, getting in close cuts out most, if not all, of the background. This makes it possible for you to work in just about any space in your home, hotel room or other location. You don't have to tidy up or clean – just move in and the clutter magically disappears. Another reason is that being close up is how you experience your intimate moments with your partner. From within this inner circle is the best way to appreciate the lovely curves of a neck, the delicate colors of a nipple, the gentle swell of a belly. When you create photographs close up, you invite the eye to touch as you touch – the proximity carries much of the erotic charge.

Full-length

The approach to the full-length body is to arrange the subject so that head and feet are at about the same distance from the camera. There are two main reasons for this. Technically, one big problem when photographing the full-length body is depth of field. It is difficult to get the whole length of a stretched-out body fully in focus. At the same time, if you position yourself at one end or the other, you will exaggerate the size of the part of the body nearest to you and so create an unnatural looking result. Of course, you can exploit this exaggeration (often, wrongly, called a distortion) for artistic effect – as English photographer Bill Brandt (1904–83) did with such great, classic effect. But the rest of us can start by arranging the whole body simply standing in front of the camera. Very fine entire œuvres of erotic portraiture have been produced using this simple approach.

So try starting from this point and see how you can develop the poses. I would advise avoiding the arch expression and overacted poses as they all too often look like the artificial travesty of the normal positions that they are. More important, always ensure that models are comfortable in their pose, at ease within themselves and able to move around freely. Then, perhaps, ask them to move – for example, to mime simple actions or go slowly through dance movements.

You may find that the full standing or leaning pose makes your partner feel awkward. If so, try a reclining position. Or else start with a seated or another pose that folds the body – one in which the model hugs himself or herself often feels the most safe, for obvious reasons. Work with the poses your model is happy with before exploring more demanding positions. And it does no harm to the imagery to crop off some of the extremities, such as the head or feet. In fact, it is acceptable to frame the image to crop off the head. Your partner

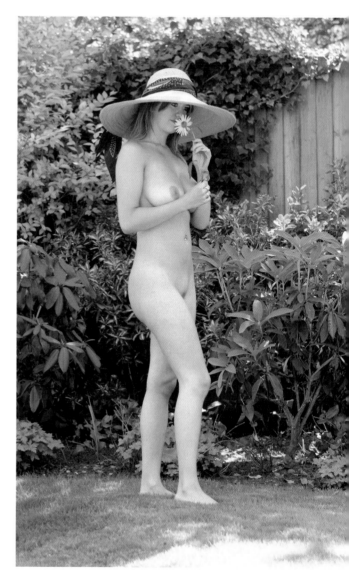

above Full-length shots are a natural choice for the erotic photographer, but it is difficult to make these poses interesting. A simple stance such as this one loses its appeal after just a little viewing because it harbors no surprises, nothing is unexpected. Try instead to get up close, to enter personal space.

may be happier, certainly in the early days, if you don't show the face or enough of the head to be recognizable. This also means you will not need to worry about the model's facial expressions.

Expressing emotion

The great thing about working with professional actors or dancers (male or female) is that they know how to express emotions through their bodies – using not only the pose and the exact position of their limbs, but also the subtle tensions in their bodies as part of the communication. Using your body to speak is something that comes more naturally to some people than others – some feel they are expressing something only with the largest of overblown gestures, whereas others can't be made to emerge from their shell however much you coax and tempt them.

This is why making a success of photographing your partner truly involves partnership and requires a good, trusting relationship. It is often a mistake (more often made by men) to issue too many orders. Just let your model be: it may take a little while for your model – male or female – to relax, to forget about being modest or shy and to start to come out of their shell.

If shyness is a problem that stubbornly will not go away, try asking your partner to think of, or visualize, something pleasant and relaxing: perhaps lying on a sunny beach, toying with erotic thoughts or just waking up from a long slumber. Imagining stepping slowly and very relaxed from a hot, soapy bath having had a long, hot soak might also work for some people. Encourage your partner to use his or her imagination to circumvent the problem. Don't give up; with patience and sympathetic posing, even shy people eventually relax.

right and overleaf A range of emotions can be captured if you work fast enough. Keep talking to your model and let the person do whatever comes easily. In this set, every shot has its charm and tells you something about the individual, but perhaps the sexiest is the only one in which she appears self-absorbed and unaware of the camera's presence.

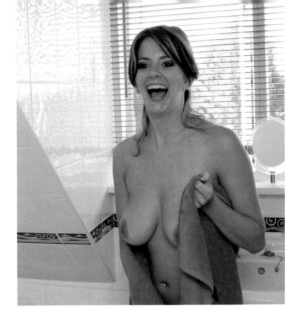

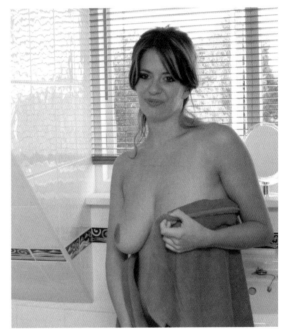

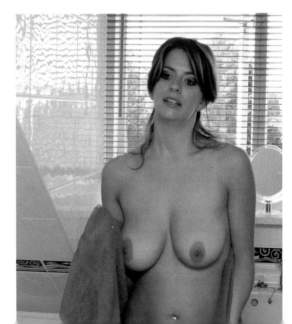

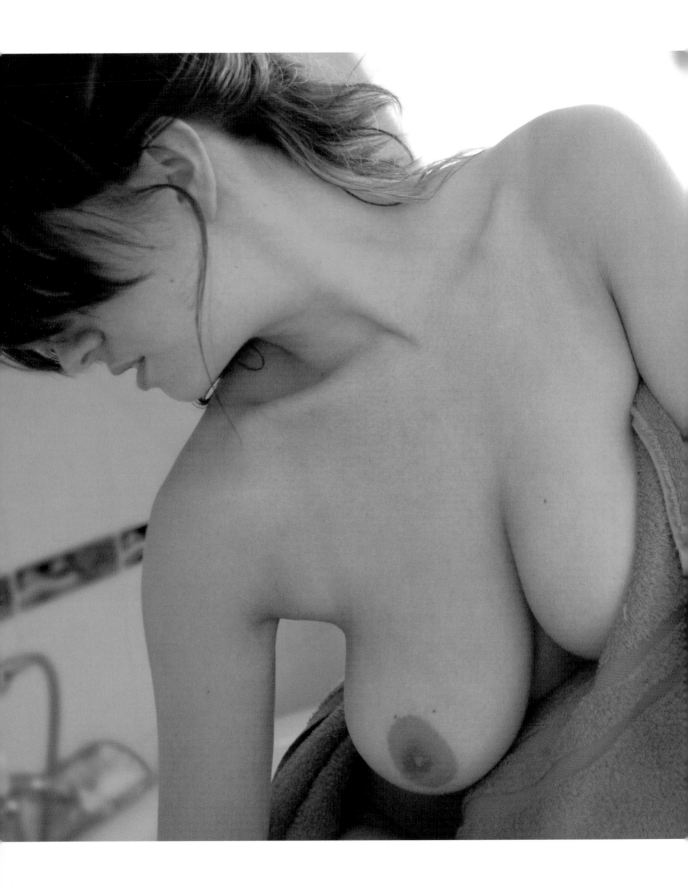

TO SMILE OR NOT TO SMILE?

We all know that the expression on a single face among many in a group photograph or family portrait can make or break the picture, so it's not hard to imagine how important facial expression can be when the subject of the picture is a full-length nude. With digital photography you can, without inhibition, ask your model to try out a whole range of expressions, recording each one and then choosing the ones you want to keep later on. You will soon discover that a fairly neutral expression is the most generally acceptable and versatile.

A smile is good once in a while, but too many images of a beaming face look false and the impact rapidly diminishes. If you want to try the sexy pout and "come-on" eyes, then ask your model for a really exaggerated expression for humor value; but use it too often and you run the risk of undermining the credibility of your images.

Making the best of yourself

We all like to look our best. Vanity may be a frailty, but it can also be a virtue when it fosters self-confidence and self-esteem. So if there is some part of your body you are embarrassed about – perhaps a scar from childhood or an area of bad skin caused by sunburn – it is no shame to hide it. You can simply choose poses or crop images so that nothing you don't want seen is in view.

Having said this, photography represents a great opportunity to confront things about yourself that you may deny or wish not to accept. This has created a whole genre of work and therapies using photography to help people deal with past traumas and emotional problems, including low self-esteem and self-destructive tendencies. This does not mean, however, that simply because you are diffident about posing in front of the camera that you have psychological problems to overcome – it is a perfectly natural inhibition – but why not take the opportunity to think about yourself and perhaps improve your self-understanding?

As the photographer, respect your model's wishes. If you can't get the shot you want, too bad. It is not worth testing your relationship just for a picture. And even if your partner does agree, still respect his or her right to delete or destroy any of the shots after reviewing them.

Using light

For the most part, light is the photographer's friend and ally. Indeed, some photographers say "all light is good light." But the human form is a fickle and demanding subject. The body is so subtle in its

textures and delicacy of form, and we are so familiar with it, that to lose details carelessly to lighting makes the lighting itself look unnatural and appear uncomfortable. Therefore, it is safer to say that, for the naked body, not all lighting is good lighting. But with care and experience you can use a wide range of illumination effects as long as you are aware of the difficulties.

The key to good lighting for the human form, at least what will keep you on the safe side, is to

right Full-on sunshine casts shadows unpredictably over the human form; the bright light distracts the viewer from the main subject and the exposure is never convincingly right. No wonder this model looks so disenchanted.

ensure that there is detail visible in both the shadows and brighter areas. This means that large areas of shadows are never fully black and expanses of brighter skin are never fully white. You can always deviate from this deliberately if you choose to, when you know what you are doing and why, in order to create low-key or high-key images, for example (see pages 50–51).

Let's look at different lighting situations and how you can approach them.

Bright sunshine

Bright sunny days are great for many activities, but not for nude photography. Bright, harsh light shows up pimples, hairs, stretch marks and all the defects we'd rather forget. If you have to shoot in bright light, use poses that stretch the skin. Sunny days also deliver high-contrast light: in direct sun there is not only a big difference between the darkest and lightest areas (a large "luminance range"), but the transitions from light to dark can also be abrupt.

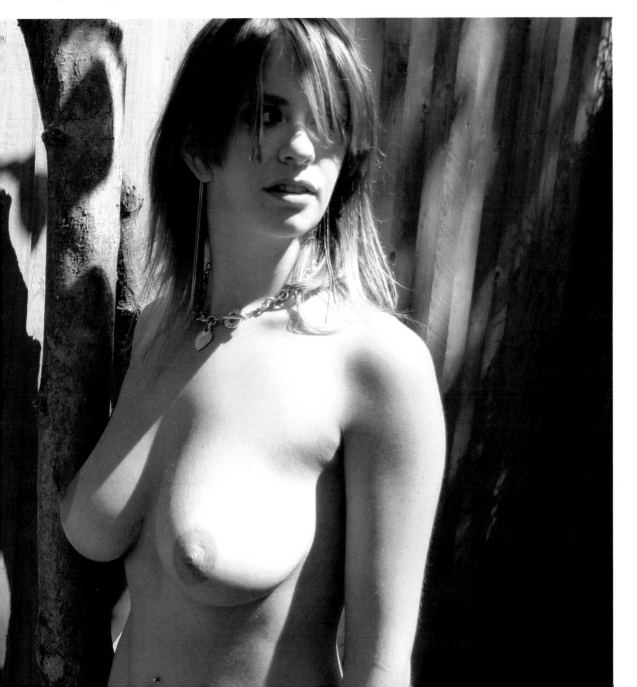

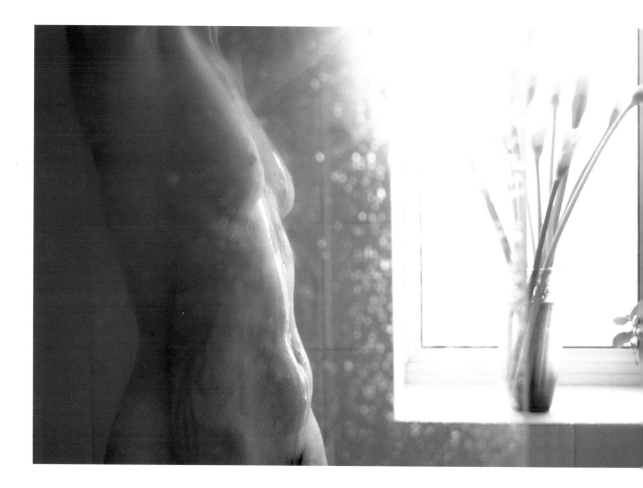

above With the afternoon sun streaming into the bathroom, and steam creating its own atmosphere, it is possible to emphasize the airy brightness of the scene by the simple expedient of giving more camera exposure than normal (overexposing the image). This results in a "high-key" image – one that is mostly bright, with few dark areas.

Having to photograph in full sunlight is enough to strike fear into the heart of even the most battle-hardened professional. If you set the camera's exposure controls for the bright areas, all of the shadowy parts of the scene then appear to be thrown into deep, dark shadow. However, if you go the other route and set exposure to allow the shadows to retain some detail, the bright areas are then transformed into glaring, burned-out white. In

addition, it is really difficult to judge where the mid-tones – which define the texture and shape – will fall, making it hard to anticipate what the shape of the subject will look like. As well as it being very tricky to judge exposure in high-contrast lighting conditions, you need to bear in mind that many digital cameras cannot handle overexposure very well. So learn from the professionals: on sunny days, head for the shadows or work indoors. There you can enjoy higher-than-normal light levels, but avoid the perils of direct sunlight.

Shadows
Like bright light in a picture, shadows also carry pitfalls for the photographer. As the light reaching into shadowed areas is not direct, it must have reflected off some surface in the general area. If

left Normally you would avoid a brilliant shaft of light appearing in a shot, such as this afternoon sunbeam that found its way through the window. But you can take advantage of accidents such as this – here the light creates a line that helps to define the figure.

this surface is a colored one, then the light it reflects will have picked up some of that color. Those lucky enough to have traveled in the Aegean may have noticed the intense quality of indoor light. Much of this is because the light reaching indoors has bounced off the ubiquitous whitewashed walls of the region and, in this example, the light is not weakened by having picked up any unwanted color.

Now, what if the light had come not from the whitewashed walls but had first been bounced from and filtered by the foliage of nearby trees? As you might expect, the color of the light would then tend toward green, which, needless to say, is not a great complement to skin tones. It is not safe to rely solely on the automatic white balance facility found on digital cameras to correct (eliminate) the green color cast. For one thing, removing the green entirely may make skin tones appear too red; for another, light will reach your subject from many different sources, so correcting for one color – say, the green – could mess up corrections for another – the blue component in the light reaching your model from an open sky, for example.

However, do not allow these technical problems to inhibit you from shooting out of doors in lush, green surroundings. Just shoot away and see what results you get. In the worst case, you will have to spend some time tinkering with color balance and correction (see the chapter Digital Tricks on pages 84–113); at best, you obtain unexpected and rewarding mixes of color. And you can always turn the image into black and white and thus sidestep any color-balance problem entirely.

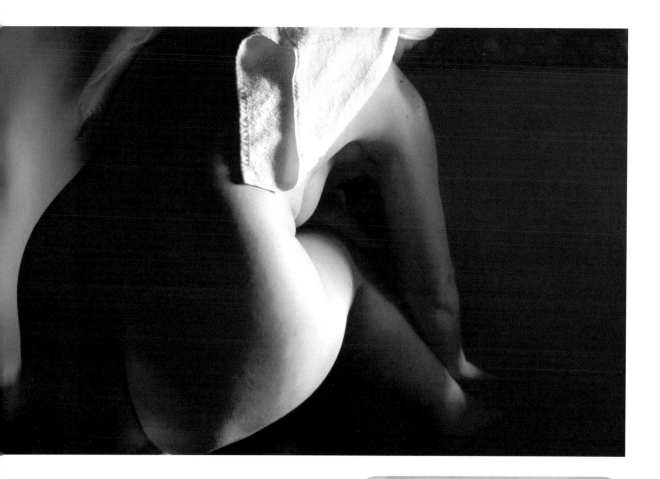

above This shot is all in the shadows – the dark areas to the left define the body yet give little away, while light from the right illuminates the body. Note that the shadows get in the way again, preventing us from seeing the full story.

Modulated light

By "modulated" I mean that the light has been transformed in quality and distribution by obstacles placed in its path. A typical example of this is light coming through half-drawn, partially translucent drapes: the resulting light is variegated – soft here, hard there, patchy in places, more even in others – and it is a delight to work with.

This is the way to make best use of sunlight streaming into a room. Left alone, it will be way too harsh to work with, but it's a shame not to make the

USING A REFLECTOR

You can master shadows with a little help from a reflector. It is not necessary to buy specialist photographic reflectors such as those commonly used by wedding or portrait photographers, although these are the best for the job as they offer different light qualities and a choice of warm or neutral tones. A very good reflector can be fashioned from a white sheet or table cloth, even a newspaper held up at the right angle for the light. Another convenient reflector is a length of bubble-wrap or a sheet of expanded polystyrene. The trouble with a reflector is that you may need an assistant to hold it up for you.

best use of it you can. Throwing a net curtain, or even a thin bedsheet or lightweight shawl, temporarily across the window is a useful trick for breaking up sunbeams. If you have slatted blinds, adjust the angle of the blades to give you a variety of lighting effects. Bear in mind, however, that the light will pick up the color of any intervening surfaces it bounces off or passes through.

Achieving good exposure

Modern cameras are very reliable when it comes to measuring exposures so if there's an error it's more likely to be the fault of the user rather than a camera problem. You can always review each shot as you go, but this hardly encourages the creative flow. Better to try these two tips instead: memory readings and bracketing. With memory reading, point the camera at precisely the area of the scene you want to get right (such as the shadows) and hold the appropriate button down – the shutter or another button depending on your camera model –

to memorize the reading, compose the picture and fire it off. With bracketing, you set the camera to expose the scene at the measured setting as well as at deliberately underexposed (too dark) and overexposed (too light) settings. You can review all the variations and keep the best version(s). Don't listen to anybody who claims that bracketing is not needed with digital cameras – it's not true.

To flash or not to flash

The harsh quality of the light from a camera-mounted flash is almost a defining characteristic of the amateurish erotic shot. It is safe to say that every time you use this type of flash (or the small

below For this shot, light from a setting sun forced its way through the shutters and onto the kitchen wall. A fleeting pose is caught as a shadow and the fortunate presence of red carnations in the foreground completes the picture. Not an obvious shot, but one that makes the viewer do some work.

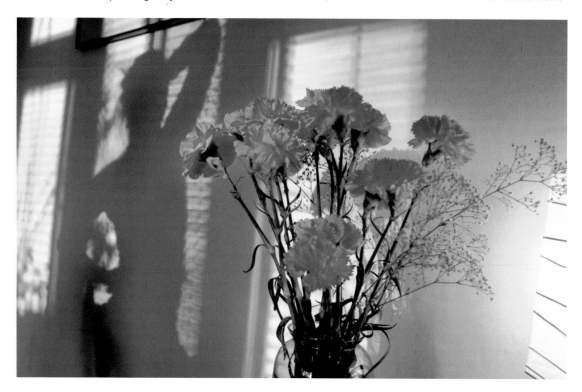

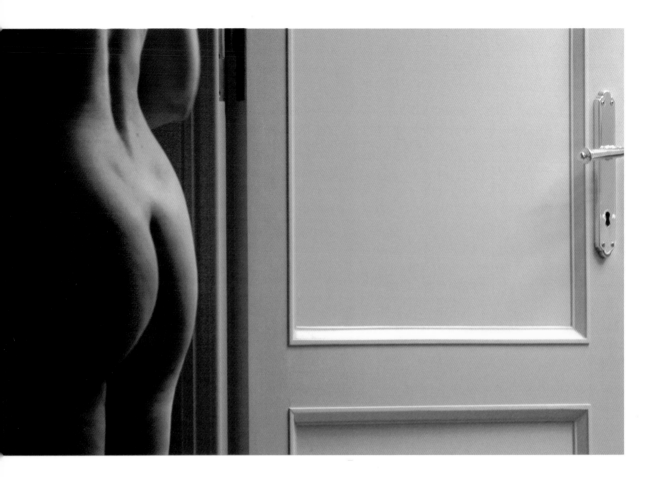

one built into the camera) you could instead use available, or ambient, light to better effect. Of course you may have to work with low light levels, but digital cameras cope with this surprisingly well.

Chiaroscuro

This lighting effect is so lovely it has its own beautiful Italian word. Chiaroscuro means literally "clear and obscure," referring to the lights and darks of a print artistically arranged to define form. Originally applied to a painting style, the word has been borrowed by photography to refer to lighting that has the effect of distributing lights and darks in an artistically pleasing and form-delineating way. Typically, then, such light falls on the subject at a low angle – as at sunrise or sunset – and in so doing accentuates even the finest textures. The

light is not overly harsh even though it is directional. The trick is to get the light to fall in such a way that it does all the work for you – outlining the form, picking out textures and guiding the exposure, which should be midway between the lightest and the darkest areas of the scene. To ensure the best results with this type of lighting it is advisable to bracket exposures (see page 53).

Take care with raking sidelighting, however, as it can pick up the slightest signs of cellulite and uneven skin texture. Try to conceal such features, if you find them embarrassing, by assigning them to the shadows. The model should try to stretch the parts of the body he or she is not confident about. Don't bend forward over a loose tummy, for example, and bend to stretch a thigh rather than drop your weight on that leg.

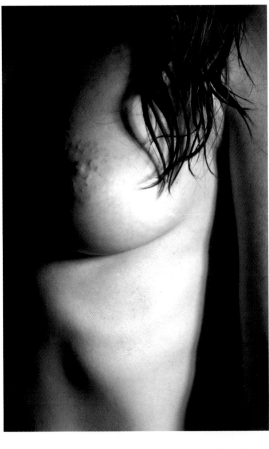

opposite You do not have to be a lighting expert to obtain a chiaroscuro effect with this type of raking light. Here, the light from an open bathroom door and an obliging partner trying to get dressed combine to deliver a gracious contrast in form and line.

left This image illustrates some of the dangers to be aware of when working with raking light. Two sources – both windows – have given a double edge to the shadows. In addition, the harsh light has given some shadows too hard an edge – on the arm, for example – although the light beautifully sculpts the breast.

Flat, soft lighting

Lighting that delivers no shadow, thus offering little modeling of form, is unrewarding for most photography – but not if the subject is the human body. Flat lighting is low in contrast, and just as high contrast is the enemy of defining form, so low contrast flatters and brings out the most delicate of features. This also means that flat lighting is the best for hiding features such as wrinkles or scars; if you don't want to see these easily, then be sure to work in flat, soft lighting. Stretching a woman's stocking over the lens can further soften blemishes or unwanted details.

You need to take care with exposure, however, since in low-contrast lighting everything has, by definition, a very similar brightness value. Thus, small errors in exposure often lead to large changes in the appearance of the image, and these changes can be difficult to correct later.

left Barely distinguishable tonal shadings form the soft lines and delicate textures of the breast in this image. Obtaining this effect required the softest of lighting – reflected from the room walls facing a sunny window, casting the body, effectively, into shadow.

Targeted focusing

You can control the viewer's gaze by manipulating where the best focus in an image lies. This works best when the depth of field (see pages 43–44) is reduced, an aspect of photography controlled through your choice of lens aperture – using a large aperture, such as f/2.8 for example, reduces depth of field to a minimum and so limits the area of the image that is acceptably sharp. However, to do this you need a camera that allows you not only to select different lens apertures, but also to set the focus very accurately – this means you need an SLR camera, either digital or film-based. If you have such a camera, targeted focusing, also known as differential focusing, is a powerful but simple method of giving images visual elegance and sophistication.

opposite The simple technique of focusing on the foreground plant instead of on the model, even though she is the main point of interest, adds an intriguing standpoint to this image – the viewer has to do a little work and is encouraged to do so because there is just enough hint of the nude form to entice closer inspection. The reward is the play of light and shape – not the body itself – and the photograph is so much the better for it.

below For best results using targeted focus or limited depth of field, you are recommended to use a digital SLR camera in which you can closely observe the image. Here the focus is on the near plants, but composed carefully with the model in the background. It is often easiest to use manual focusing in these circumstances.

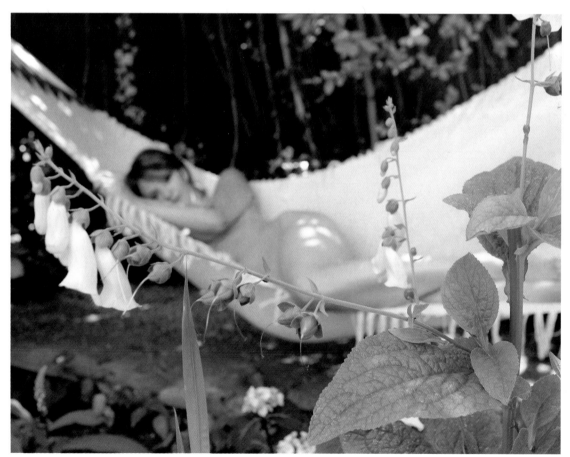

Using locations

A new location involves not only a change in physical place, but also a change in your thought processes and imagination. That is why travel is at the core of photography. A new location means not just different backgrounds, but a whole new light, a fresh atmosphere and, perhaps most importantly, the potential for creating different moods and pictorial effects. More than just recording whatever is directly in front of the lens, a photograph also records everything that sneaks into the frame as part of the background. The whole atmosphere and mood of the precise moment of the shot is there – though signs of this may be subtle. And be sure, too, that when you create an image you find successful, it will be one enriched with good feelings, warmed by the spark of shared inspiration.

Beds

The danger of using a bed as a prop (no, not that you will end up in it together) is that it has a natural tendency to produce a "fixed perspective" – one in which the photographer stands up and the model lies down. Aim to overcome this by injecting some variety into your work: stand on a chair for a higher viewpoint or sit on the floor for a lower one. You can also use the bed as a stage to carry blankets, pillows or even stuffed toys to add to the variety, taking you far from the more predictable and prosaic under-the-sheets type of shot.

Try as many different and adventurous poses as you both feel comfortable with: the bed allows everything from fully standing to fully lying; fully curled up as well as various sitting, stretching and reclining positions. As your model experiments with different postures, just keep shooting.

Sofas

The various corners, backs and cushions of sofas all give you great posing opportunities – your model can recline, stretch, curl up, sit on the cushions, the back or arms, hug cushions, and so on. You may want to cover the sofa with some form of throw before starting, both to protect the furniture from marks and scuffs and to introduce materials with new colors, contrasts of textures and shapes.

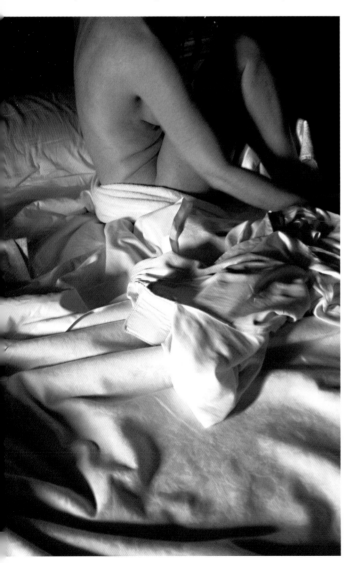

left An untidy bed is a photographer's delight, so don't tidy it up before the session starts. Note here how the textures of the linen and the soft colors contrast with and echo playfully the textures and shape of the woman's skin and body.

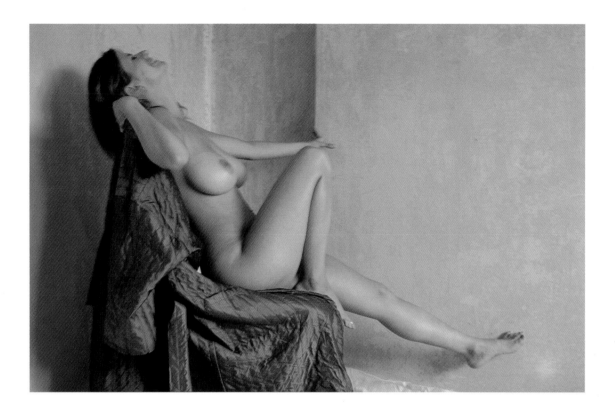

above The rigid lines of a kitchen chair proved too obtrusive, so curves and folds – and color – were added by draping a dressing gown over the chair.

You will find that neutral-colored sofas, or those with very subdued colors – dark browns, black or cream – are the easiest to work with. For a start, they clash least with skin color and, additionally, they transfer little of their color to your model. But don't feel inhibited if your furniture is covered with, say, vivid primary colors. Instead, use the opportunity to experiment with fun accessories – hats, boas, boots, outlandish nail polish – and enter into the mood generated by the sofa color.

Chairs and seats

You need to select and position a chair or seat carefully for it to work well as a prop. The chair typically becomes a major player in the shot – the famous photograph of Christine Keeler, whose sexual liaison with a British cabinet minister plunged the government into crisis in the 1960s, can't be imagined with, say, an ordinary kitchen chair. Although Keeler would have been just as beautiful, the chic elegance of the image is all down to the modernist lines of that chair. In the same vein, Liza Minnelli's pose straddling a chair on stage in a scene from the film *Cabaret* exudes sexuality.

Don't neglect the fact that a chair requires an appropriate background (unlike a bed or sofa, which provides its own). Will you exploit a Laura Ashley-type floral wallpaper pattern? Or perhaps you have to work with those Regency-striped wallpapers found in some period-style hotel rooms. If possible, look for a plain wall, but beware of baseboards and dado and picture rails, all of which can be distracting features intruding into the shot. Even experienced photographers have been known to overlook the electrical outlet or an obvious crack in the wall directly behind the model's chair.

Hotel rooms

One of the most refreshing changes of scene is a vacation, especially if you are booked into an unfamiliar hotel room. Even though it is true that most hotels offer little to inspire the creative spirit, the simple change of scene itself may be just the spark to fire your imagination.

The most important consideration when shooting erotic images in a hotel room is that it is the one place you can be sure to be left alone. Turn off the cell phone, hang the "Do not disturb" sign outside your room, lock the door and you should be pretty safe from interference. Then, with both of you relaxed and far away from day-to-day distractions, even a room with dull furnishings can be one in which you create great pictures.

Bathrooms

Don't forget to clear up the usual bathroom clutter: what starts looking like "keeping things natural" soon becomes a nuisance, which at best requires a lot of image manipulation at a later stage or at worst irretrievably spoils the picture. A good tip is that bubbles not only look good in the bath, they also prevent the water looking murky and gray – even when the water is actually perfectly clear.

opposite If the hotel has a large, well-decorated bathroom, just combine a shoot with your usual ablutions. This was shot almost without interrupting evening preparations – just follow your partner while he or she gets ready for a shower, occasionally offering suggestions and encouragement.

below The fine chrome finish of the bath attracted us immediately as a contrast to skin tones and body shape, and the painted toenails are a perfect touch. But note that the water does not look clean, even though it was, thanks simply to the gray color imparted by the shadows.

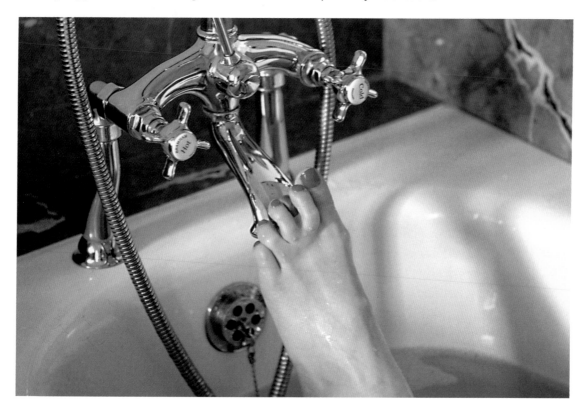

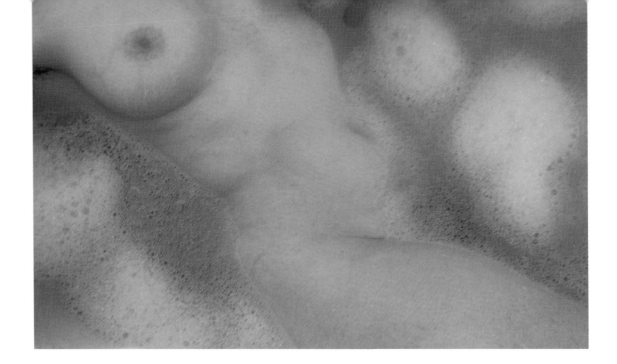

above The simplest of compositions – here a beautiful body positioned across the picture diagonal, with the corners filled by bubbles – often has the most impact. The slight movement of the bubbles during the longish exposure adds visual interest to this intimate bathtime scene. No flash was used, even though the shot was taken in a dimly-lit bathroom, as the artificial illumination would have destroyed the soft, warm quality of the natural, low-level daylight.

below Don't get so carried away with the play of light and water on the body that you fail to notice the homely clutter of objects. This image is not really helped by the presence of the plant and bottles.

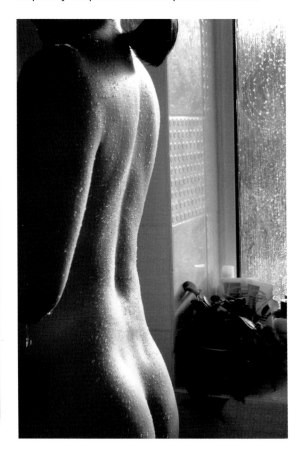

COPING WITH STEAM

If your camera is at a lower temperature than the steam from a hot shower or bath, then condensation is sure to be a problem. Not only will the eyepiece fog, but water droplets will also form on the lens. Don't worry, a little condensation won't harm the camera – but large drops of water may. The solution is to warm the camera before you take into a steamy atmosphere. To do this, wrap it in a plastic bag, take it into the bathroom and wait a few minutes for it to warm up before opening the bag and removing the acclimatized camera.

Gardens

As the location of pretty flowers and as a refuge offering seclusion from prying eyes, a garden or enclosed backyard seems an ideal place for private photography. And so it is. But in it may lie concealed a few traps for the unwary.

The alluringly complicated lines from leaves and flickering shadows offer many photographic possibilities, and a garden is also often at its most attractive in full and brilliant sunlight. But sunny lighting conditions are not the most attractive or easiest in which to work for nude photography (see page 49). In addition, brilliant spots of color from out-of-focus flowers in the background will present strong distractions from the naked body. The process of ensuring that the background details complement and work with the soft tones of the body can be tricky.

Another problem is lawns. In black and white, the green tones of the grass are often very close to that of the skin, particularly if the model is tanned or has a dark skin tone. This means you may have to work harder to delineate the body. At the same time, the darkish gray of the grass plus its coarse texture is seldom very attractive. How many great pictures of nudes on a lawn have you ever seen? And consider the model's comfort. You won't make yourself popular if you force him or her to stand uncomfortably in the flower beds.

Working in color, the problems from the grass may be even worse. The greenish blue cast from

below Simple outdoor furniture or even a fence can offer opportunities to contrast skin textures and colors with the rougher textures found in and around the garden.

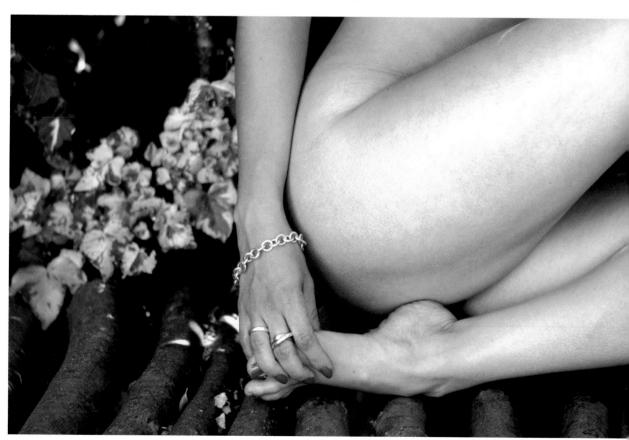

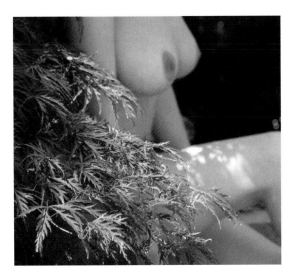

above In the close confines of the garden it may be difficult to get everything in focus. But, instead of complaining about it, you can try to make use of what the process (and photographic optics) offers you. This beautiful body is none the worse for being upstaged by the fine leaves of a Japanese maple.

the grass is just about the worst possible color to scatter over beautiful skin tones, unlike reddish or even blue tones which have their uses. It is never attractive, so ignore a green cast at peril of your artistic reputation. On top of that, it is very difficult to remove the green cast without damaging the skin tones at the same time (see the chapter Digital Tricks on pages 84–113).

Sea and dunes

The combination of sun, sea and surf with relaxing times on vacation produces thoughts that naturally tend toward a celebration of your partner's beauty. The trouble is finding a little privacy if you are vacationing in one of the more popular resorts, so you may have to go a little off the beaten track to discover somewhere you feel relaxed enough to strip down. In some countries particular beaches are designated for nude sunbathing, but even here you must take care not to include other beach users in your shots who might not want to be photographed. Even if you travel to exotic locations – Morocco, the Red Sea or Malaysia, for example – you may still find a total prohibition on nudity.

You don't have to take your clothes off to make erotic shots of each other. What is sexier than a beautiful body in a swimsuit? And if it's all right to be in skimpy swimwear, you could always whip off the tops or bottoms for a few quick shots before anyone notices. Trying to avoid detection can add to the fun, but don't attempt this where you could be in serious trouble if you are caught.

In Europe and northern climates the enemies are the weather – it is too cold too often – and privacy (these countries can be heavily populated). Assuming you manage to find a secluded spot, sea and sand dunes are perfect backdrops for the human form – if it's good enough for some the greatest photographers, it should be good enough for you.

When exposing parts of your body to the sun, especially those that are normally covered up, it is sensible to take precautions. Make sure your model is well protected from ultraviolet (UV) light by using a high-SPF sunscreen. Take particular care with skin that is normally clothed as it will burn more readily. Keep the sessions short, or he or she may burn. Aside from limiting any more photography sessions for some days to come, a sunburn could put the model's health at risk or even be permanently disfiguring.

Bright light and a very pale-skinned subject will tend to make the camera underexpose – the camera will overcompensate for the high light levels and select a smaller lens aperture or shorter shutter time. Many modern cameras, especially the more sophisticated ones, will compensate automatically for these conditions, but it may still be necessary to dial in extra exposure – for example, +1 or +1.5 – using the camera's exposure-compensation control.

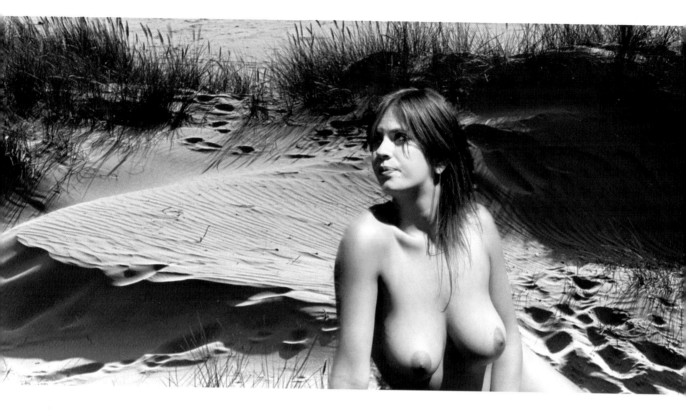

In addition, both sand and high levels of sunshine can cause camera-related problems. Always keep sand well away from your camera. The fine contacts of the memory cards only need one grain in the wrong place to be rendered useless. And spray from the sea can drift hundreds of feet as microscopic droplets and settle on your equipment, leaving salt particles behind as they evaporate. This salt is the equivalent of being attacked by parasites as far as photographic equipment is concerned. So start with a fresh memory card with lots of capacity to avoid having to swap them on the beach and, if at all possible, avoid exposing the delicate inner working of your camera to sand and salt by not changing lenses on the beach.

Finally, do not try to make the LCD screen as bright as possible: it will still be difficult to use and you'll drain the batteries; use the viewfinder instead and review the pictures only indoors.

above If the beach is busy with visitors, shoot the promising locations anyway. You can drop in the model later using manipulation software.

FILL-IN FLASH

Shooting in the open in full, bright sunshine can result in harsh, hard-edged shadows. To minimize this type of problem, allow your camera's built-in flash to "fill in" the shadows. To do this, simply turn the flash on and let the automatic system direct a little light to relieve the shadows (on some cameras you have to select the flash fill-in option manually). It may seem silly to use flash in the bright conditions being described here, but this is exactly when flash can be most useful. Check the results on the LCD screen if you are using a digital camera.

Forests and woods

Wooded areas can be so full of variety, changing dramatically not only during the course of a single day, but also from season to season, that it is possible to spend an entire lifetime photographing in just a small area without ever running out of inspiration. For the adventurous couple, forests provide many photographic possibilities (see pages 34–35). It is far easier to find seclusion in this type of landscape than it is, for example, on a beach, and other forest users usually make enough noise to be heard from some distance away. Do, however, become aware of any legal restrictions if you are on national parkland or private grounds.

Photographically speaking, working under leafy cover presents a number of technical considerations. Apart from the problem of light filtering through a green canopy of leaves and picking up a greenish color cast (see pages 50–51), the contrast is high between shadowy and sunlit areas of the scene, a situation that is always difficult to set an exposure for. More of a problem is that any very bright areas in the background behind your model can be extremely distracting to the finished shot. The effect on the image of these highlights is not easy to evaluate on the small screen of a digital camera, but with practice you will learn to avoid them – or at least to ensure that highlights are not too close to the model's face or head.

left It was only after the model removed her clothes that we realized there was a very obvious bikini line to contend with. One way to handle this situation is to make it less visible. Here I focused on the fine curves of the grasses, throwing the body well out of focus, thanks to the very long focal length setting on the zoom. The body becomes almost the incidental feature, less important than the graceful blades of grass.

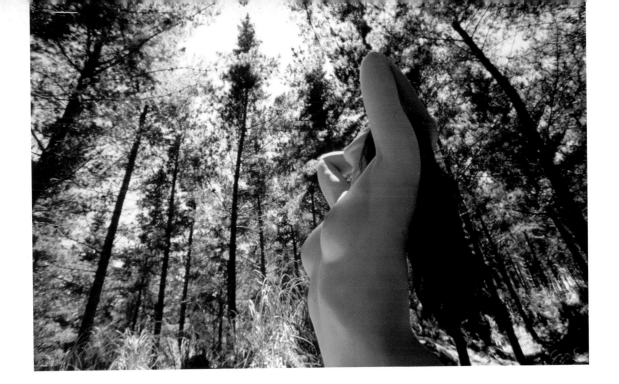

Using a long focal length setting

One way to deal with any distractions or intruding landscape features in the background, which is always a problem when working in a forest, is to use a long focal length setting but also to work closer to your model. This technique throws the background well out of focus, thus softening the features. However, do take care to hold the camera steadily so that your images are not spoiled by unsharpness caused by camera movement during exposure.

above It is usually not advisable to get in too close to the human form using an ultra-wide-angle lens setting – one that takes in a broad, expansive view – because it tends to produce a rather unflattering image, with the parts of the body that are closest to the lens appearing much larger than those that are further away. In this instance, however, we wanted to convey a sense of space and of being at one with the forest, so we wanted the image to include the trees soaring overhead.

opposite The exceptionally fine, long blades of grass offered an obvious counterpoint to the extensive, smooth, rounded tones of the model's strong back. A long focal length lens setting on the zoom, the longest available, produced a shallow depth of field, leaving the grass sharply rendered and the model softly out of focus. The emphasis here is on the tones rather than the detail.

left The use of a long focal length setting on a zoom lens – about 300 mm 35 mm equivalent focal length – has thrown the distracting background well out of focus, despite the fact that it was less than a yard from the model.

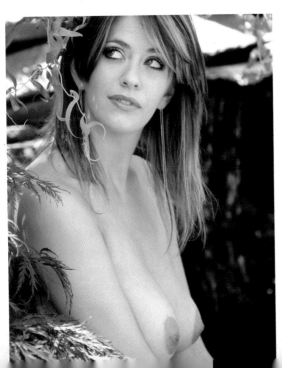

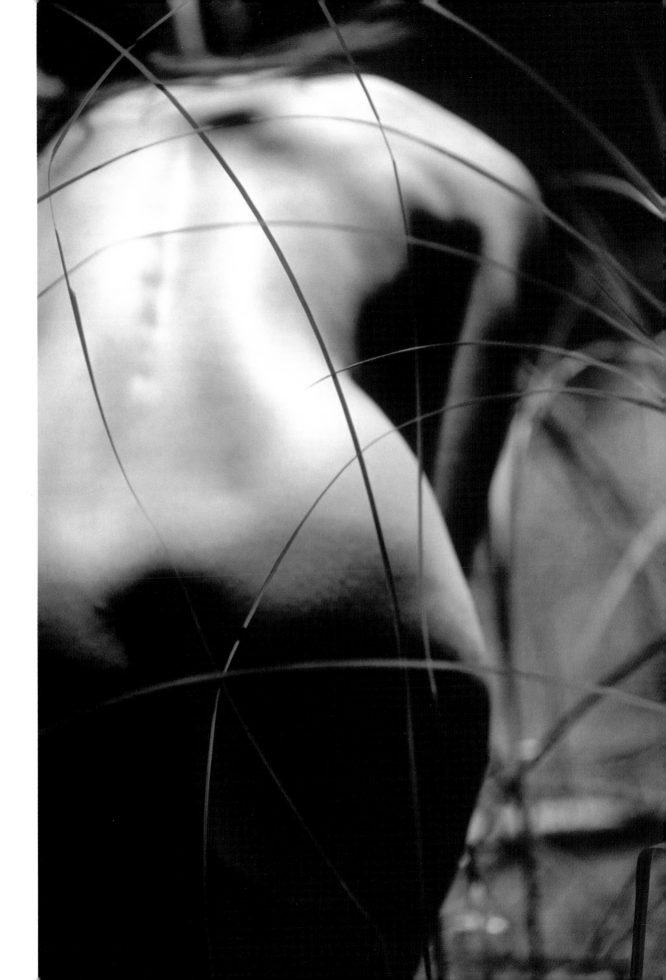

Using color

Successful color photography involves working with and using color creatively, rather than merely copying a scene in color. Color is not something incidental, any more than is texture or indeed the quality of light. This means seeing color as the way in which a scene expresses itself to you, so that it is integral to your experience of the subject. You need to learn to see the colors themselves separately from the things that display them.

You could try to approach your photography as if it is the color that is the subject, and the body almost incidental. This single change in mental focus could radically transform the way you work.

Working with adjacent colors

Colors that are immediately to the left or right of a color on the color wheel (see opposite) such as light and dark green with yellow or blue, purple and cyan, are adjacent colors. A combination of these is always pleasing to the eye and easy to work with because they come together to harmonize and bind disparate elements.

One type of adjacent-color composition would be a largely monochromatic scene – one in which all the visible colors are of a similar hue. This color scheme offers tonal subtlety instead of high color contrasts: the various shades of a tanned skin with the warm off-whites of sand can blend beautifully, for example.

Working with color contrasts

Color contrasts are produced when you combine colors that are not adjacent to each other on the color wheel. While compositions featuring strong

below Working with colors could mean you look at your sofa in a completely different way. Imagine this shot on a green, blue or purple sofa: nothing wrong with the sofa, but the effect of those colors on the beauty of the body may not be as complimentary as this richly red one.

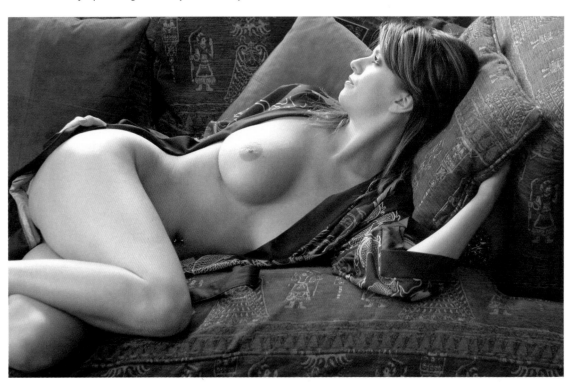

right The color wheel shows which colors are adjacent and work well together, such as violets with reds, and which are contrasting, such as blues and oranges.

colors may initially be appealing at first hand, they are not particularly easy to organize into a successful image, especially if the subject is all delicate skin tones and curving lines.

Modern digital cameras can capture wonderfully vibrant colors that look fantastic on the computer screen. In fact, most of these colors are brighter and more saturated than film can possibly record.

The resulting intense colors are attractive to the eye and always make an impact when incorporated in designs. However, their strength means that you must use them with care, as strong colors will compete with anything else in sight. Furthermore, you must be constantly aware that even if you can see intense and strong colors on the computer's monitor screen, you may not be able to reproduce them on paper. Purples, sky blue, oranges and brilliant greens all tend to print poorly on paper, looking far duller or darker than they appear on screen.

below It is hard to imagine this image working with anything but the blue-colored mosquito net, as the effect depends on contrasts of color to distinguish form, define distance and create atmosphere.

below The salmon pink towel color is not that far removed from the model's skin tone – just deeper and richer. This closeness of color links the towel and body, counteracting the contrast of textures.

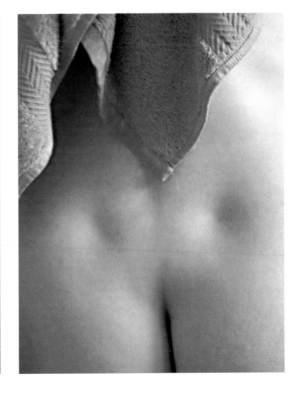

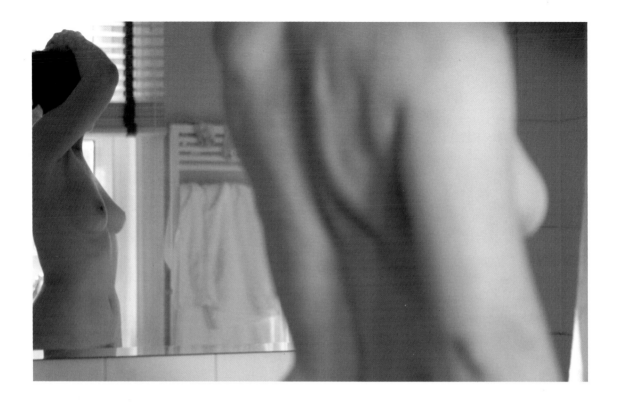

Working with pastel colors

Pastel shades should not be regarded as weak or delicate versions of "true" colors. Pastels contain a large portion of white and so are certainly less saturated or vibrant, but they are nonetheless vital tools for the photographer.

Weak or less saturated colors suggest softness and calm; they are gentle whereas strong colors are vigorous. Pastels, therefore, evoke responses that other types of color do not, and they are also important as counters to strong colors. Skin tones are primarily pastels – pink skin tones being less-saturated versions of reds; oriental skin tones being light versions of golds or yellow-browns – but darker skins can be richly colored when viewed in bright light. Generally you want to match strengths of colors as well as control the range of colors, and working with pastels is the easiest way.

opposite By restricting the palette to yellows, the color balance here is strongly warm.

above Strong or vivid colors would not be appropriate in this quiet shot, in which the model has been left to get on with her routine. Note that the mirror allows us to see the one pose from two different angles.

OFF-WHITE BALANCE

A deliberate off-white balance is an advanced technique available on some cameras. Normally, the camera automatically balances the prevailing color of light to make neutral colors appear neutral. But you can force the camera to make your images deliberately cool or bluish in color; alternatively, you can ensure that all your shots are a warm reddish or orange overall. Consult your digital camera's manual on how to set white or color balance. If you are using film, an equivalent effect can be achieved by using a colored lens filter.

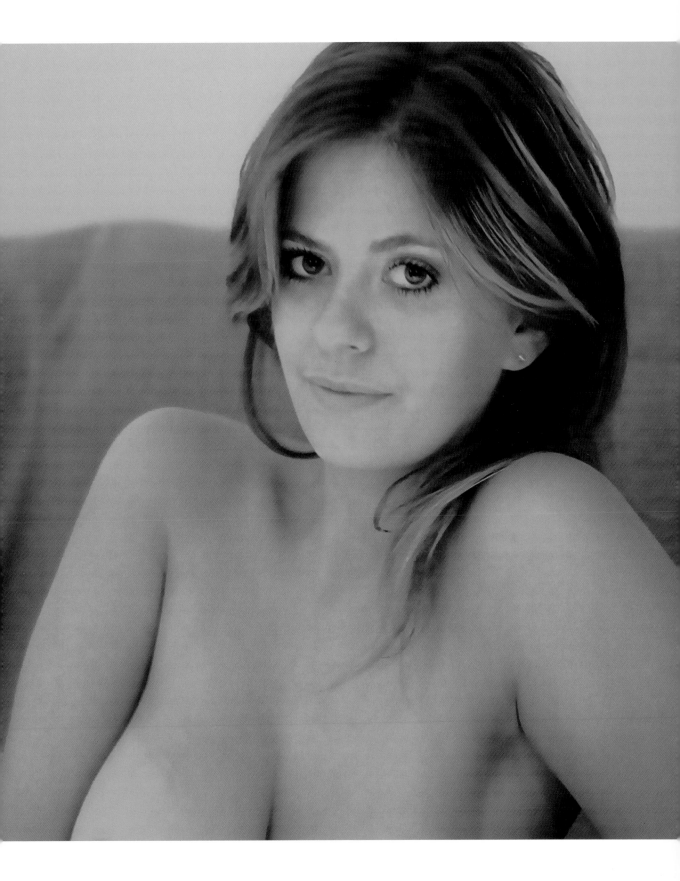

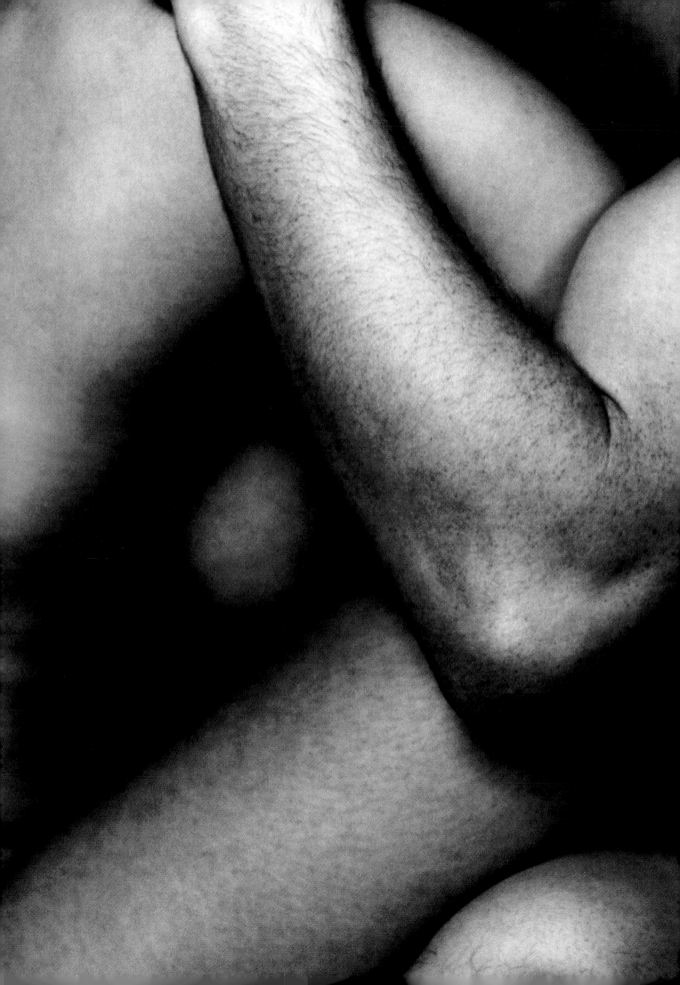

4

just the
two of us

In this chapter we discover ways in which both of you can be included in the picture without involving a third person. You may find the thought of having a camera watch over you rather unsettling, but often people enjoy it after a while. And with today's technology, you don't even have to keep your finger on the shutter button, thus removing a potential distraction you don't really need. The method described here involves setting the camera up to take shots every few seconds (however, this is not possible with all camera types and models). This is very different from shooting a video of you and your partner. For one thing, image quality can be far, far better than even the most costly, professional-standard video camera. For another, trying to grab a still frame from a video is not as easy as it sounds (technically and aesthetically).

Setting up a tripod

The key accessory for this process is some form of support – accurately called a *stativ* in several European languages. All you need is something that keeps the camera static, so a tripod is not strictly necessary. However, you will soon discover that using a tripod is infinitely more convenient than trying to balance the camera on top of a bureau, wedging folded train tickets under it to point it down toward the bed.

Inexpensive and simple, a basic tripod will do the trick. The majority of digital cameras are very small and lightweight, so the demands made on the tripod are not exacting (see page 125 for more information about tripods). Check that your digital camera possesses a tripod mount – usually a ¼-inch (6 mm) screw thread on the camera's baseplate into which you screw the tripod head. Some of the smaller digital cameras do not have this thread, but they are so lightweight you can safely stick the camera to a tripod using a lump of adhesive putty-like material or strong, double-sided adhesive tape.

Aim the camera so that it amply takes in the whole scene. You should frame the shots leaving some room for you and your partner to move about without worrying about falling out of shot (moving out of the field of view of the camera lens). Another, and to some people a more erotic, approach is to tighten the framing so that instead of taking in the whole scene you record just a close-up. In this case, it is better to set the zoom lens of the camera to a long focal length setting – to magnify the image more – than to move the camera in closer. This is because focusing from a greater distance is easier for the camera to handle without error. In addition, a long focal length perspective is likely to be more flattering. As you gain more experience, try experimenting with using wide-angle (short focal length) settings with the camera closer in. The image perspective will be radically different and the results usually more unusual and interesting.

How to take the shots

Digital as well as film-based cameras can be triggered using a wireless release – something like a television or hi-fi remote control. These are not common, however, and can be expensive to buy. As most digital cameras can be connected directly to a computer, the computer can be set up to

trigger the camera via a hand-operated remote control. This is often not easy to set up, however, and you must take care that the extension cable does not end up in shot.

Make sure that both of you take turns with the remote control so not just one of you is controlling the timing of the shots. Whoever is in charge of the remote release may be likely to feel they have the upper hand. Just agree to take turns – all should be kept fair in love and photography.

Another approach is to set the camera to time-lapse (if available). This allows the camera to take pictures automatically at preselected intervals. This is probably the most fun way of working as the introduction of an element of chance means you can't be exactly sure when the camera is going

below Taking shots of yourself can be rather like making recordings of your voice, but instead of saying "Do I sound like THAT?", you ask, "Is that US?"

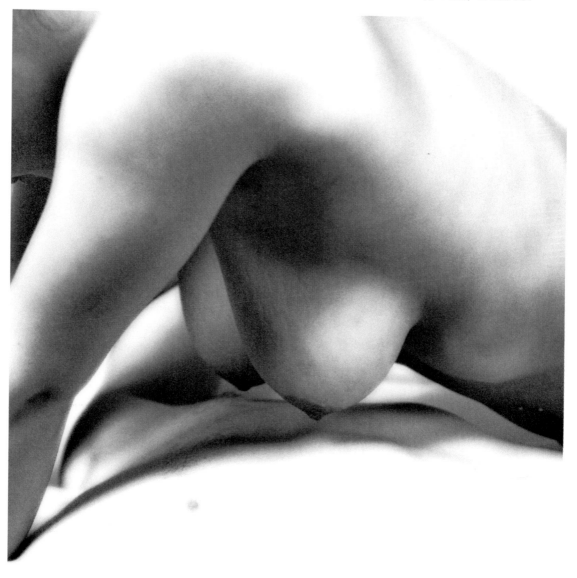

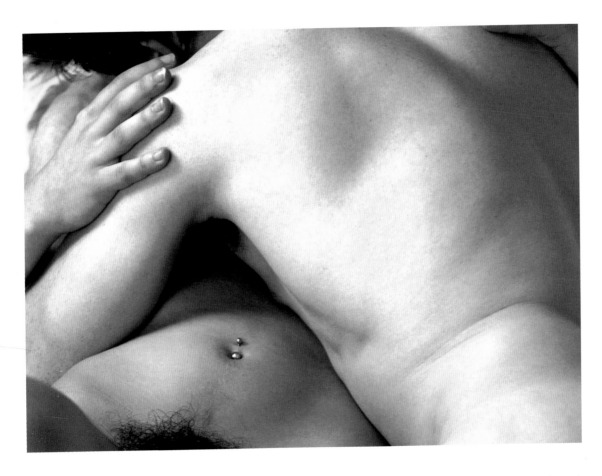

to fire (unless you manually time the intervals, which is rather counterproductive). Afterwards you should both review the shots and simply delete any you don't want to keep – another example of the beautiful economy of digital photography.

Composing yourself

It is infinitely easier to tell someone how to arrange themselves into an attractive or flattering pose than to assume the position yourself, sight unseen. And it is doubly difficult when there's two of you with no visual feedback. But there's a solution. While it can be fun to pose "blind," it can also be rather frustrating if the results offer no promise, so make it easier on yourselves by placing a mirror above the bed. Of course, the view is not that of the camera's, but with practice you should be able to adjust to the camera's shooting position.

above If you let in a third party – whether it's the camera's electronic controls or another person – be prepared to make images that you might not like. If you find yourself at all discomfited by the process, perhaps it's time to stop proceedings and discuss it again (see also the Agreement, page 14).

TIPS FOR SELF-TIMED SHOTS
- Set the camera to take lots of shots – they're all free with digital!
- Use soft, flat lighting, and attempt sidelighting only once you have gained more experience.
- Try different positions – not only is it fun to experiment, but it helps the photography.
- Power the camera from the main electrical outlet as it's staying in one place.

Some digital cameras offer a swivelling LCD monitor, which can be swung round to face the same direction as the lens; that way, you can see yourselves on the screen. However, these screens are usually rather small and difficult to view from more than several feet away.

Failing these aids, it's best to position the camera where a photographer would normally stand – not right at your feet nor at your heads, as pictures taken from these positions distort body proportions. A higher angle is generally more versatile than one that is level with your bodies – and a tall tripod is a help here. Finally, don't forget that experimenting is part of the fun – just go with the pictures you get.

below Letting someone else do the photography means you become a voyeur to yourself. Weird or instructive? It depends on you, your partner and, above all, the photographer.

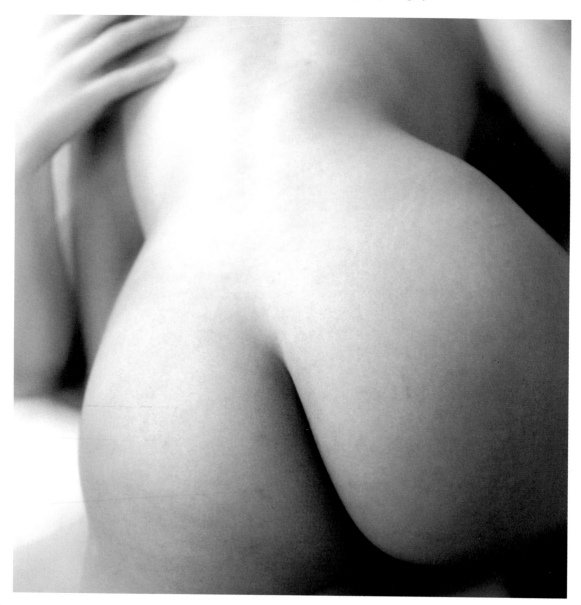

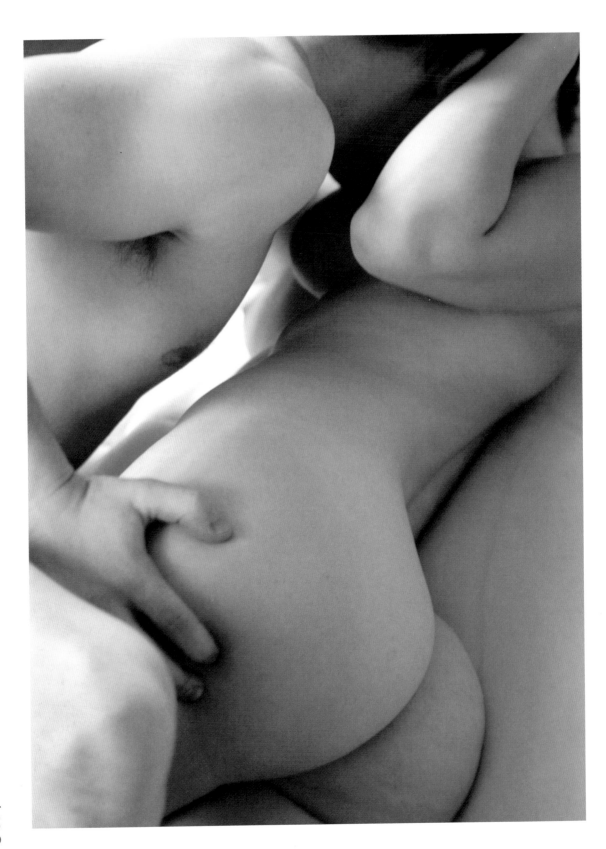

Light levels

Today's digital cameras can keep working continuously for an hour or two at most, so it is a good idea to load a fully charged battery before starting a session. To ensure the camera delivers short exposures – this will minimize the possibility of blurring caused by subject movement during the actual exposure (remember if you don't know when the shot is being taken, you can't hold still) – you need to flood the room with lots of light. But even if you turn on every light in the room, typical domestic lights still need supplementing. This is an example where pragmatism and aesthetics in photography need to be balanced, as with all this light splashing around, the atmosphere is unlikely to be very romantic.

You can improve matters considerably by using as much light as possible, but stopping before it becomes clinical, and then selecting a high sensitivity on your digital camera. So instead of setting ISO 100 or 200, for example, try setting ISO 800. Check your digital camera's instructions for details of how to do this on your particular model.

Image quality

It is time for a warning about premature erasure, otherwise known as unwanted image deletion. Allow time for reflection before you decide to erase any image, however obviously bad it might be. Once it is gone, there is no turning back – at least not without a great deal of effort. Bear in mind that all pictures do not have to be technically perfect – sharp, ideally exposed and free from unwanted movement. The pictures should simply express something about the joys of your partnership.

opposite Pictures of the two of you require a little more effort but are worth it, as the experience can be enriching and the results a lasting testament to your passion for each other.

You may find that images with some technical imperfections make interesting subjects for digital manipulation – you don't need the detail if you are going to manipulate the image heavily by applying textures or fun effects, for example, or by radically altering an image's color content and balance. In fact, it's arguable that if you have a lovely, sharp shot you should respect it and, at most, strive only to improve it by correcting colors or exposure if necessary. But an imperfect image is fair game; rather than trying to retrieve a poor image, you are using it as the basis for further work. In this way you minimize the waste of images.

below Shifting subjects during a longish exposure inspired this manipulation – overall exposure was increased to lighten the image: necessary, or else the blur tends to be hidden.

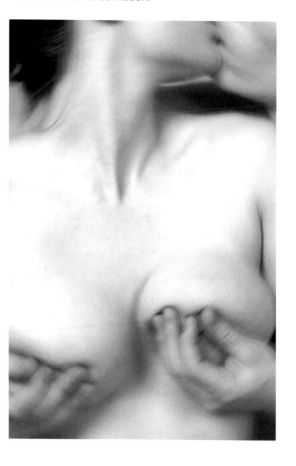

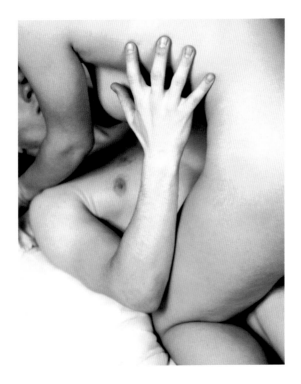

Digital video

Another option is to use a video camera. Naturally you simply place the camera on a tripod, point it in the right general direction and play in front of it. But there is a cost to this convenience. Firstly if you want single shots, you may have to wade through many minutes of video to find it. This could of course be fun in itself – but what often happens is that you end up with numerous similar-looking shots, and then you have to make a selection from all of these.

Another more intractable problem is that the quality of image from all but the latest, best and most costly of video cameras is very inferior compared to even very simple, inexpensive digital cameras. A typical digital video "still" image is low in resolution (a million pixels is big news, compared to the norm of over three million with digital cameras), details are poor due to the way a video signal is sampled, and the color quality is markedly inferior to digital still photography.

left The problem with having your cuddles recorded is that all the awkward bits are uncensored and preserved. On the other hand, you can accept them, or rather yourselves, as is.

But if you already own a digital video camcorder, it offers an option worth some exploration. But our recommendation, given the current state of digital video equipment, is not to spend too much time or money on it.

Another kind of third party

Let us not forget someone else who may have an important place in your household: your pet. The contrast of skin and fur – their differing textures – can be an interesting play, visually. And there is endless variety to be found in the differences in shape between animals and people. There are some points to watch, however. All have to do with putting the animal's interests first – and the condition of your patience a close second.

Try to involve your pet at a sensible time – when they want to play or are happy to be held. Most animals move fast and somehow know exactly when you're about to trip the shutter, so just keep shooting. If your camera is firing off its flash, try a few dummy flashes with your animal relaxed so that you do not startle it. It could snap at you, extend its claws or simply decide it doesn't like this game and exit stage left very quickly.

The high-pitched sound of autofocus and other camera mechanisms can also upset some animals, although others can be intrigued by the little squeaks and whines – if so, you can work out how to use that information to get your shot.

opposite One danger is that the pet becomes the star of the session – and you might decide to create a pet photographic album solely devoted to this treasured family member.

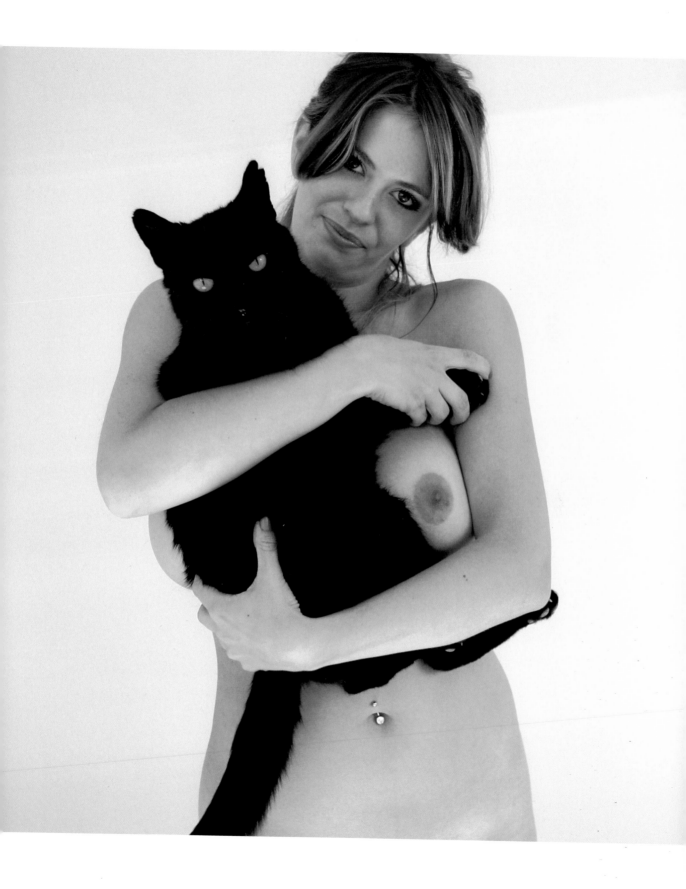

5
digital
tricks

Working digitally not only means that you are self-sufficient and not dependent on any outside processing lab or printing service, as you would be with traditional film-based photography (essential considering the often intimate nature of the subject matter), but it also offers you numerous opportunities for working directly on the image itself. This chapter covers just the essential corrections and manipulations involved in digital camera work, as there are numerous reference books explaining image manipulation in greater depth (see Resources, page 128).

Basic guidelines

Always bear in mind that what you do to a recorded image may be destructive to the data of which that image is composed. This means that the more you work on an image, the lower will be its picture quality. So, should you wish to retrace your steps and return to the original image you may find you cannot. Here are some guidelines to help you avoid some of the obvious disasters.

- **Create a work folder.** The first job before you open any images is to create a new folder, just waiting to be filled with great work. Use this folder to save your duplicate images and any working files.

- **Always work on a copy.** Before you open an image you want to manipulate, the first action to take is either to duplicate it or, better still, to copy it to your work folder. Then open the copy image from your image-manipulation software after navigating to the appropriate work folder.

- **Use small files for learning.** While you are becoming accustomed to how your image-manipulation software works, start by making small files of copies of your images. This is a useful exercise in itself

as you will learn how to do one of the fundamental tasks of digital photography. Make your image about 1,000 pixels in length on the long side, keeping the other side in proportion. This enables the computer to work most quickly while you are experimenting (the larger the picture file, the more processing time it takes for the computer to manipulate it). As you build up experience or when you work on images properly, the software will work more slowly but by then you'll know what it is doing and why.

Cropping the picture

Considering how vitally important the overall shape of the picture is, bounded as it is by the rigid straight sides of a rectangle, it is hardly surprising that the most powerful changes come from altering picture shape. In particular, the basic cropping, or reduction in the size, of a picture is the simplest but most significant change you can make to an image. Countless numbers of pictures could be improved by the simple expedient of a little skillful cropping. And this control is available in every image-manipulation software on the market.

The effect of cropping is to remove unwanted, distracting or plain, boring regions of an image – which are often found at the periphery – to bring

the viewer's eye and attention closer to what really matters in the picture. If you crop in from all sides in proportion to the image format, you are effectively zooming in (this is exactly what so-called digital zooms do). If, however, you crop more from one side or another, but in proportion to the overall shape, you are actually making subtle changes of perspective, making it seem as if you are viewing the picture from a slightly different position. Finally, if you crop without maintaining proportions you change the shape of the image, which also offers powerful potential. As you can see, cropping alone can completely change the sense – the context – of the finished picture.

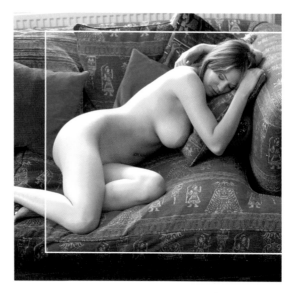

below This long, lithe body calls for a graceful shot to capture the model's essential elegance. But we can take it further by a drastic crop that removes all the non-essentials and emphasizes the slim body supported by the hammock.

above The kindest cut of all: remove all parts of the photograph that you don't want to see (the radiator behind the sofa, in this case) in order to keep your eye on the main event. Any image-manipulation software can do this for you.

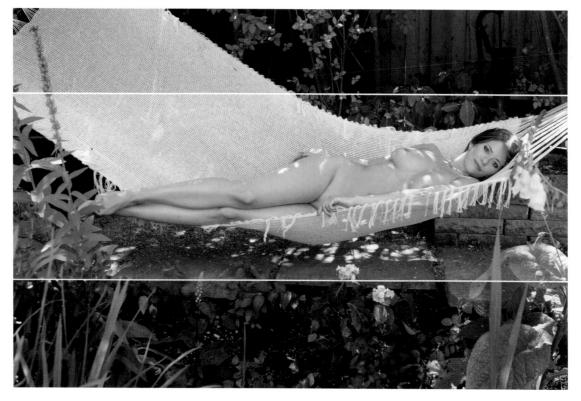

Correcting exposure

Images that are badly exposed – either too dark or too light – are as much a problem in digital photography as they are in film-based photography. The range of corrections you can make is limited but simple. Furthermore, you can always see what you're doing as the monitor gives instant feedback.

All image-manipulation software allows you to correct exposure, also called Levels. Sometimes a simple click on the Levels "auto" function will do the trick. Some software also offers a Brightness/Contrast control. These are linked together because brightness – the overall level of light in the image – and contrast – the relationship between lights and darks in the image – are closely related. Textbooks on image manipulation often tell you to avoid the Brightness/Contrast control – rightly so, as it is particularly destructive to image data – but it can be useful if you want to see quick results.

There are, however, limits to what image-manipulation software can do. If there is no information, usually in the deepest shadows and in the brightest highlights, then there's nothing the software can do to help. The image may be improved overall, but the areas without data – those lacking picture detail – will remain blank.

Unfortunately that's not all. In shadow areas, your digital camera has an electronic struggle: while trying to see into the dark at the picture-taking stage, it may read things that are not actually there (exactly as we do when we peer into deep shadow). The result is called electronic "noise." This tends to break up even areas of black tone creating an uneven or a patchy black in which somewhat lighter areas or specks do not relate to detail in the subject. Noise is created by errors in the electronics of your digital camera or scanner.

opposite The original shot was actually perfectly exposed, but a decision to emphasize the water droplets was made to improve the image. By decreasing exposure – making the darks darker – not only is the water given more impact, but the light playing on the body's curves is also accentuated.

below left and right An attempt to catch an informal shot (the subject was on the run, trying to get dressed for dinner) while working in dim light resulted in an underexposed image (left). After a simple increase in brightness overall using the image-manipulation software, the woman is revealed in all her disheveled charm (right).

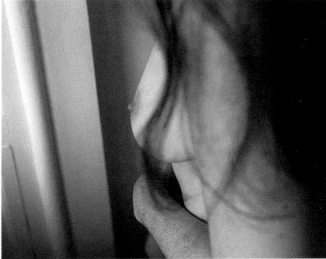

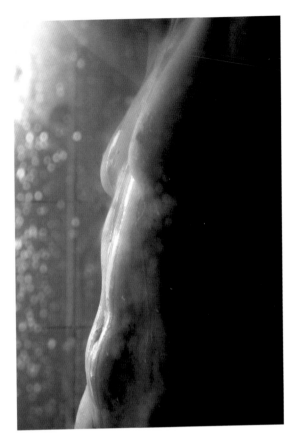

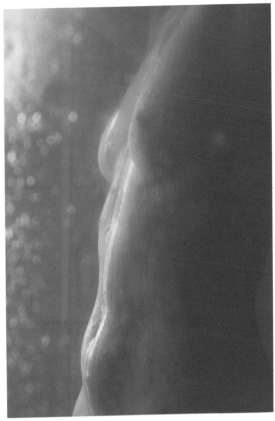

Improving contrast

Contrast in this context measures the rate at which tones change from light to dark, or vice versa, over the image as a whole. If there is not a great difference between the brightest and the darkest parts of the image, then the rate of change cannot be as rapid compared with an image that displays a large difference between light and dark. For instance, on a cloudy day, the brightest parts of the scene are usually in the clouds. These can never be as bright as the direct sun of a cloudless day. At the same time, the shadows produced on a cloudy day are not as dark as on a sunny day, thanks to the overall diffusion of light caused by the light-scattering effect of the cloud cover.

The key point is that with image-manipulation software you have the opportunity to influence image contrast to help improve images. The

above left and right The original image (left), with its sharply contrasted lights and darks, may seem too dramatic, too hard, for the subject matter. To soften the photograph (right), a considerable reduction in contrast was applied by reducing blacks to dark grays and the whites to light grays. Now you have the delicious dilemma of deciding which version you prefer.

process of capturing images – whether on film, via the photosensors in a digital camera or when scanning – tends to reduce contrast. It is only fair, then, that we put the contrast we experienced in the original back into the recorded image.

This procedure is not difficult to do, although it is a little more involved than altering image brightness. The first technique is to find the Levels function in your particular software package and

change the settings or slider controls so that the blacks become blacker and the whites whiter. You may also want to readjust the exposure. Another method is to use the Curves function – call up the control, click on the curve near the middle of the graph that you see in the display and then pull it up and down, watching all the time to see what happens to the image. Depending on the software you have, limitations are built in to restrict what you can do, so it is best that you refer to your software manufacturer's instructions.

below left and right Applying high contrast can be an effective way to clean up clutter from an image, and in doing so guide the viewer's eyes to the essentials. At the same time, the brilliant colors, which are the by-products of high contrast, create a graphic image. Compare the dull colors of the basic shot (left), with the strong hues in the high-contrast version (right).

Take care when adjusting the contrast to avoid overdoing the effect. Although very high-contrast images may look funky and lively on screen, you soon tire of them after a little viewing; a photograph with just the right amount of contrast, however, can be a joy forever. Strong contrast effects take attention away from the person, from the model, and makes you look at abstract picture attributes, such as color and form. This can be an interesting technique if you want to create a purely abstract, graphic quality in your photograph.

And don't forget that you can create interesting images by deliberately lowering the contrast, too – this softens the image and can be the perfect treatment for tasteful nude photography, creating subtle nuances and atmosphere. Because the usual intention of nude photography is to focus on the naked body, it may be safe to say when in doubt, reduce the contrast for erotic portrait photography rather than increase it.

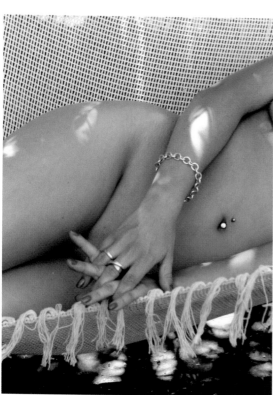 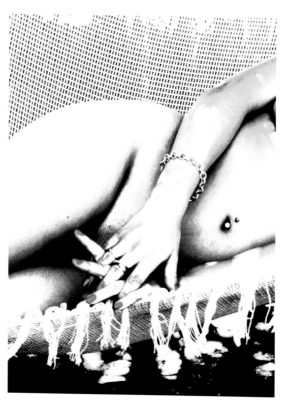

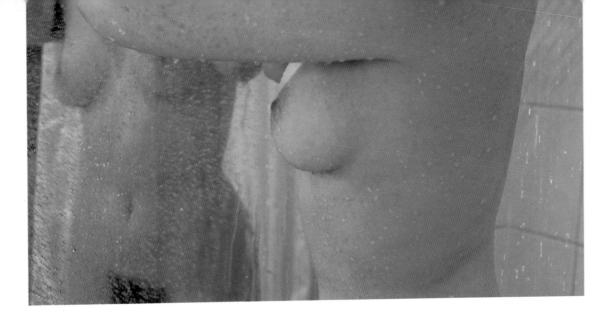

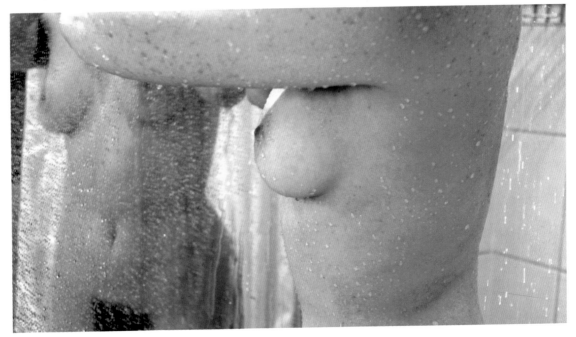

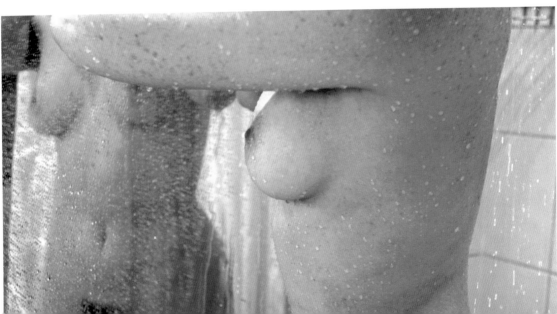

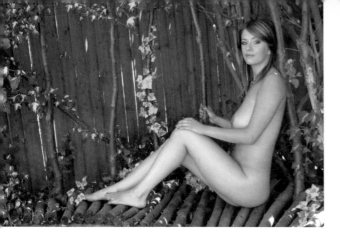 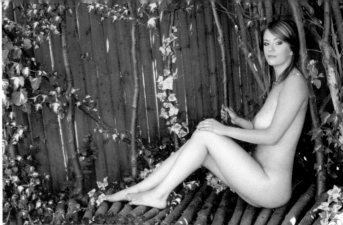

Correcting colors

Modern digital cameras are superb at producing accurate colors in a variety of lighting situations – from cloudy to sunny days, in shade or in full sun. Although many will give you accurate colors in really tough conditions, such as indoors under dim lamps (which produce a very orangey type of light) or in factories lit by fluorescent tubes (which produce a greenish light), there are limits to what they can do. The difficulties lie where there is a mix of lighting, and the worst is when the greenish light reflected from grass and filtered through leaves is combined with daylight. Green tones present special problems because they do no favors to skin tones, but removing an overall green cast can distort skin coloration by making it appear too red.

Another common problem is the orangey cast delivered by normal incandescent lamps found in domestic lighting. If you don't expect it, images can appear alarmingly yellow-red. Surprisingly quickly, however, you find yourself growing used to it, to the extent that a fully color-corrected image does not look quite right. It is a matter of personal taste how much you reduce the yellow-red while preserving some of the cast to maintain mood and atmosphere.

opposite top to bottom In the recorded image of the subject under ceiling lights (top), there is a strong yellow-red color cast. If we fully correct the color cast (middle), the image looks fine but is lacking in warmth. If we don't fully remove the warm cast, the resulting image (bottom), is more appealing.

above left and right When viewed in isolation even an image with a strong color cast (left), is likely to appear acceptable because our vision adjusts to make skin tones look the way we know they should. But when placed next to a corrected image (right), the green pallor is immediately obvious.

The most straightforward approach to correcting color is to use the Color Balance function: find this control in your software's menus and adjust the sliders until you obtain a result you like. Keep an eye on the most important colors, such as skin tones or known neutrals. Once these are right, you generally have to accept the colors in the rest of the image, even if they are not perfect. Color correction is as much an art as a science, and it is tricky. For more details, it is best to consult one of the many books on photo-retouching or working with sophisticated software such as Photoshop or Paintshop (see Resources, page 128).

SPECIAL SOFTWARE

The best technical method for color correction is to use special software that analyzes the image before applying any change. The best-known example is the Intellihance software, which works within the Photoshop application. Simpler, but still extremely capable little programs, which again work within Photoshop, are the versions of iCorrect from Pictographics.

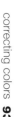

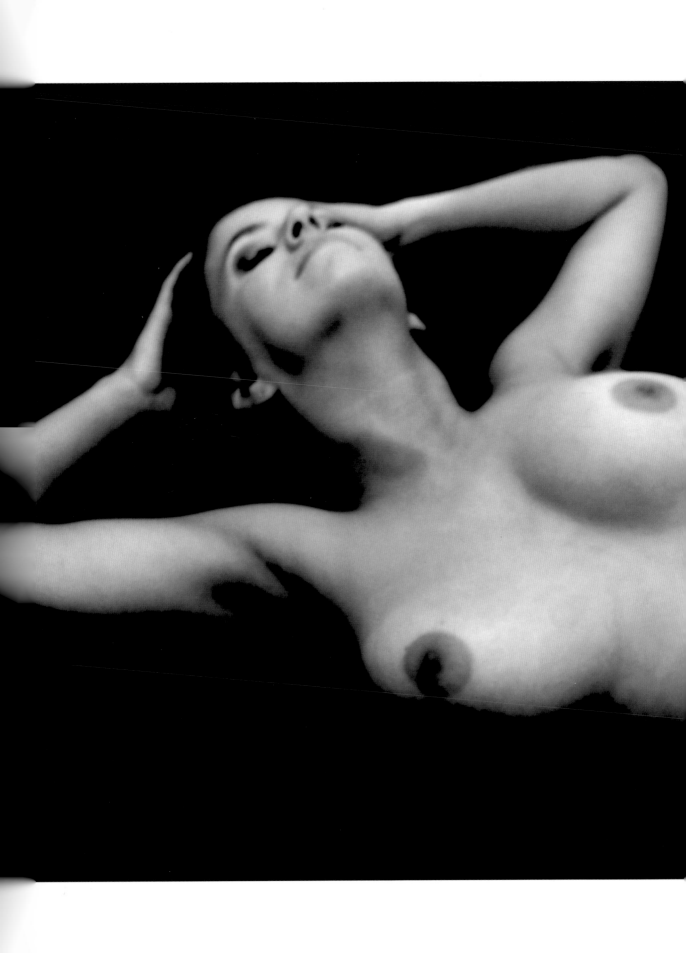

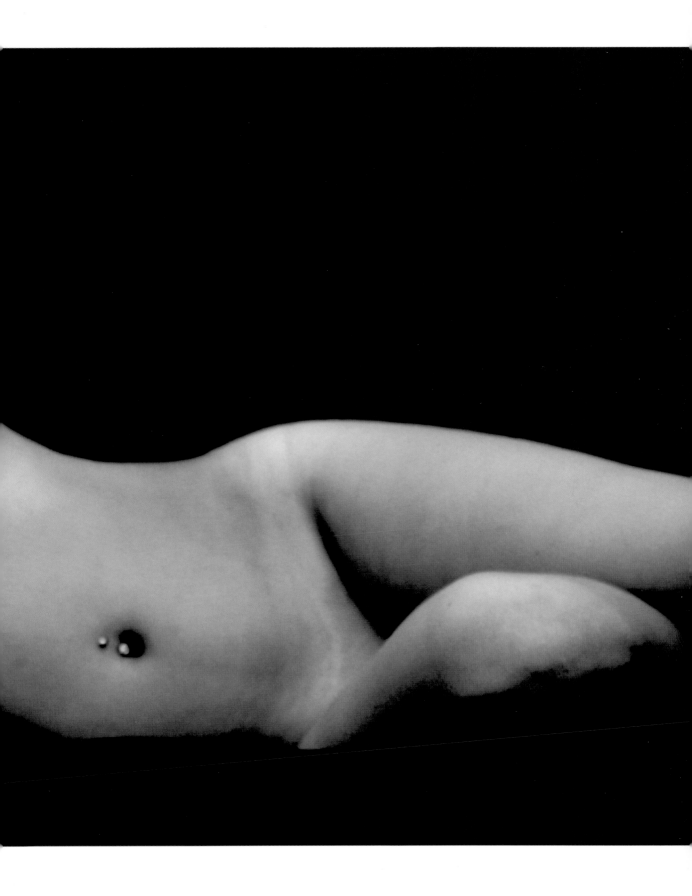

Image manipulation

The techniques discussed so far have been largely limited to general improvements in the appearance of an image or adjustments to highlight a certain aspect of it. After you have gained some experience in using these techniques, you will no doubt want to discover what more the software has to offer. These can take image manipulation much further than the simple overcorrection of contrast discussed on page 90: they start to add significantly to the content and presentation of the image. Up to this point we have discussed what is, in effect, image editing – the process of making an image "read" properly – but now we enter the realms of image manipulation, in which we creatively intervene to add or subtract elements from its content, adding to it, or removing features from it.

Improving colors

Colors can be improved in one of two directions. They may be made richer and more saturated so that they appear purer and stronger. Alternatively, the colors may be made paler, less pure or less saturated. With the human form, you can usually err on the side of making colors less pure, as you can seldom have skin too weakly colored. After all, the ultimate weakly-colored image is one converted to grays, which is entirely acceptable of course, if not often preferable (see page 100). On the other hand, oversaturated skin tones are almost always unattractive, likely to show up image defects and they are also less likely to print out well.

An overenthusiastic increase in color saturation also quickly leads to image artifacts. This is when certain details of the image start to break up, with unnatural patches of pure colors being produced. Furthermore, what you see on screen may be impossible to print out, leading to more disappointment.

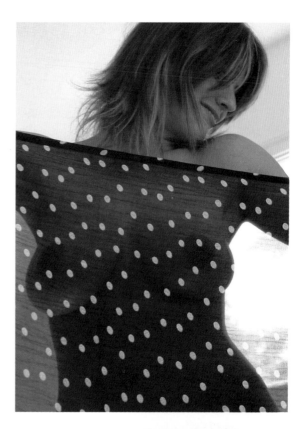

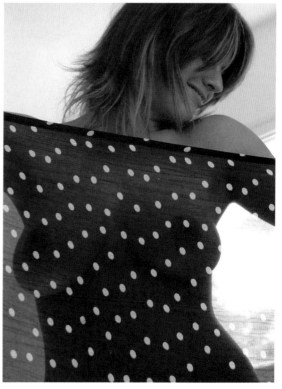

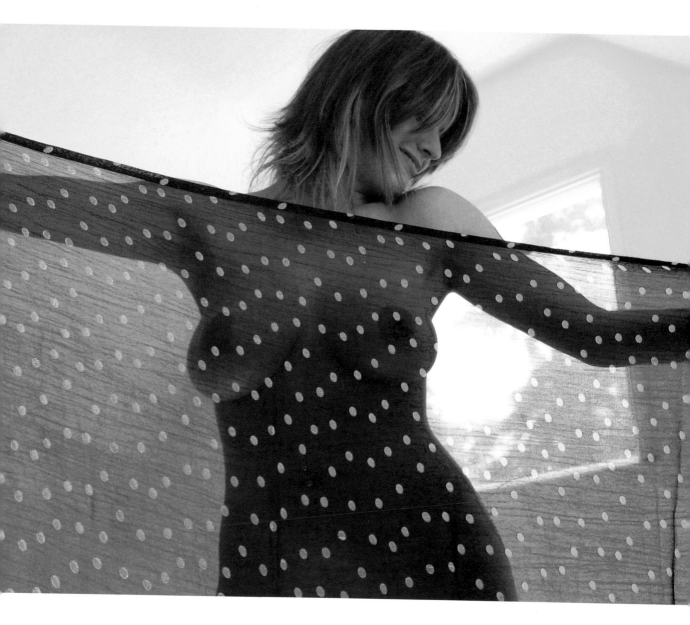

opposite top and bottom The image as originally captured (top), shows normal skin tones, but when you see it on screen or in print form you may be tempted to "improve" or play with the tones. If you make the image paler (bottom), you can go as far with this as you like – until it is all but gray – and still the image charms.

above Alternatively, an overenthusiastic increase in saturation is tempting, because with each step the image becomes more vibrant and lively, encouraging you to take the color even further – until it is too much. Not only are the skin tones too strong, but defects in the image – look carefully at the blue spots – are exaggerated.

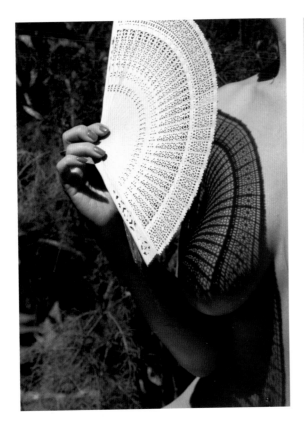

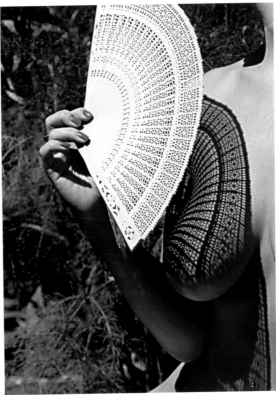

Improving sharpness

It is all very well to blame the technical processes of image capture for causing a lack of picture sharpness, but the fact is that most problems arise from human error. Often, for example, we focus on the wrong part of the image by not taking into account that automatic focusing systems are set to hunt for the parts of the image that are both high in contrast and near the camera. These mistakes are not easy to rectify, and if the error is serious you cannot expect to fully recover detail. It is simply lost. With less serious errors there are things you can do, and although the software cannot recover detail that is not there in the image, it can present what is available in the best possible light.

The simplest method for improving the apparent sharpness overall is to disguise the problem by reducing the size of the image. If the image is seen much smaller than normal, even a badly out-of-

above left and right As a side-product of the process, sharpening can produce more or less subtle effects on the tonal quality of the image. In fact, it is the minute tonal adjustments that improve the appearance of sharpness. Here, the intricate pattern of the fan's shadow benefits from a bit of help from Unsharp Masking.

UNSHARP MASKING

This technique is named after a traditional darkroom technique that was practiced by only a few photographers and understood by even fewer. The important thing is that it worked and miraculously improved the sharpness of prints. The digital equivalent goes further, adding a degree of control and ease that are light-years from the secrets of a traditional darkroom.

focus picture can appear acceptable. One of the reasons that the most popular print size is the postcard is because it disguises most blur without sacrificing too much detail.

The mainstay for improving sharpness with image-manipulation software is the Unsharp Mask. This confusingly named technique is used by everything from digital cameras through scanners to software for video film. It works by increasing the contrast at the edges of detail. For example, you can see an eyelash because a strip of darkness stops and a patch of lighter image begins. Between the two zones is a line of transition: by increasing contrast here, the image of the eyelash can be made to look sharper.

Most image-manipulation software offers an Unsharp Mask feature: look under the filters or special effects menu and you will be offered two or three different sliders or settings. Experiment

with these to see which give the best results. A good start is a strength of 100, a radius of 1 and a threshold of 10: this gives a modest boost to the majority of images – so modest you may not notice it – without accentuating unwanted grain or noise.

Oversharpening is similar to overcontrast: it can look attractive on screen but the final result seldom stands the test of time or looks attractive when printed out. You could always experiment with dramatic oversharpening as a special effect.

below left and right Rushed focusing led to the plane of focus falling in front of the model (left), so that the front of the sofa is sharp, but the model's face is not. All but the sharp part of the sofa was selected and then the Unsharp Mask function applied. This improved matters, but more sharpening might look unnatural. To complete the job (right), those areas that were most sharp were blurred.

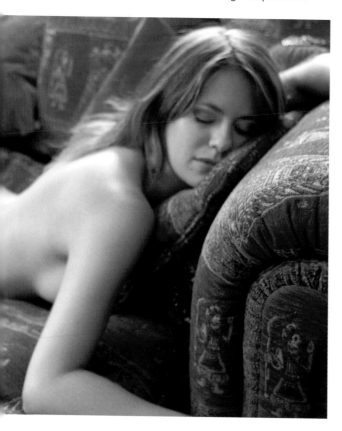
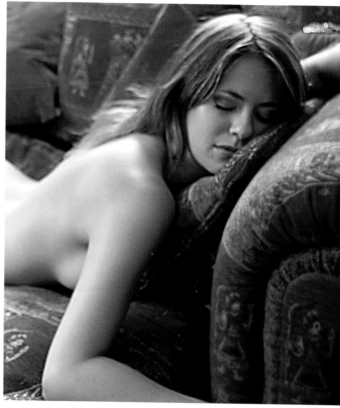

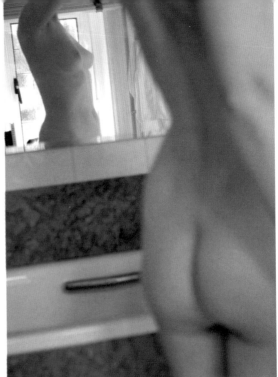

Black-and-white effects

The other major change we can make to an image is to turn it from color into black and white, but since photography was born in black and white, you may not think of this as an image manipulation at all. In essence, digital cameras "see" in color, so now we have a reversal of the original process in that the black and white image is obtained through our manipulation, rather than as a direct product of the photographic process.

In practice, there are many advantages to working in black and white. The most obvious is that you can forget about being distracted by dreadfully colored walls and the clashing colors of furnishings and drapes in a room (they will all look different shades of tasteful gray). In addition, all those white-balance problems disappear.

If your camera is able to record images directly in black and white, not only will the camera work much faster than usual, the files sizes will also be a third or more smaller. This means you will be able to fit nearly three times as many images onto a given memory card than if you were recording in color at the same resolution.

above left The simplest shots with no color often offer the most long-lasting satisfaction, presenting the beauty of the subject with as little elaboration as possible. In this way, the viewer's relationship is with the subject, not the way he or she is depicted.

above right An effective image-manipulation trick is to turn just part of the image into grayscale, as here: the figure in the mirror was left alone, but the rest of the image was turned to black and white. The easiest method is to use a Brush or Sponge tool set to desaturate (to remove color).

Turning color into black and white

All image-manipulation software allows you to turn a colored image into black and white, but note that there are advantages to keeping the black-and-white image recorded with color data, as contradictory as that may seem. This is because you can change the tone of the image – making it warm or cool, or even colored – at will. A black-and-white image printed from color data is often of more visual interest than the same image printed only from black and white (technically called "grayscale") data.

Sepia tones

Another effective manipulation technique to experiment with is turning a photographic image into a sepia version. The sepia tone is created by replacing the blacks and grays with a dark brownish-purplish color. There are numerous ways to accomplish this, but the simplest method of all is to use a specific Sepia filter. The filter can be found in virtually all image-manipulation software because the sepia tone effect is a highly popular image transformation. In fact, some cameras even offer sepia tone as a setting, allowing you to take sepia-toned pictures without any additional manipulation.

Traditionally, the reddish brown tones of old-fashioned prints were created using special sulfur-based chemicals. But don't worry, you can easily create such effects in the computer without having to touch a drop of water or a bottle of chemicals. Sepia-toning tools are available in all but the most basic software packages, and the steps for transforming a color photographic image are as follows:

1 Using the Saturation control button, which is usually linked with the Hue control, desaturate the colors (that is, make them all gray tones), but avoid turning the image into a black and white one that contains no color data at all.

2 Next, select the Color Balance control on your screen and use this to make the image a reddish brown color: you will generally increase the amount of red and add a little yellow to personal taste. You may find that a touch of green helps, too. Try various settings and just choose the one that looks good to you – a fair degree of experimenting will be necessary.

3 Finally adjust the overall brightness (exposure) of the image – old sepia prints tend to be slightly flat (lacking in contrast), and with shadows more dark reddish brown in color than black.

left Here the starting point was a color image of a couple. The colors were first desaturated; that is, made into their gray equivalents. Then the Color Balancing controls were used to make the image much more red. Finally, working with the Levels control, exposure was adjusted to make the image brighter overall.

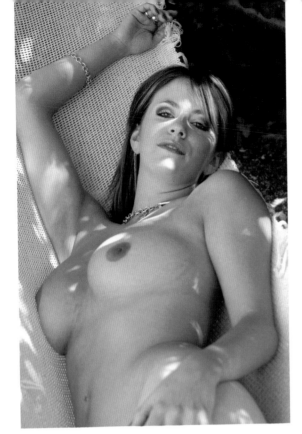

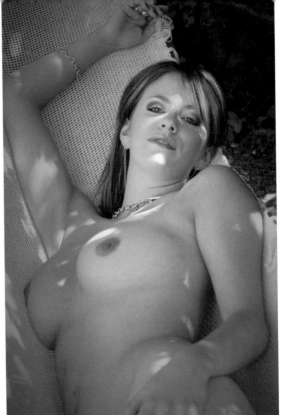

Vignetting

In photography a "vignette" is a lightened halo effect around the center of an image, gradually darkening into the far corners. It is a variant of the frame and is a popular and rather effective way of guiding (some would say "forcing") the viewer's attention toward the center of the photograph. Many image-manipulation applications offer vignetting effects of various types and they are fun to experiment with.

The most controllable method of applying vignettes is to create one yourself using the Gradients function (if your software offers it). Start with weak gradients at low opacities, or strengths, and "paint" them onto the image progressively. Effects built up slowly and steadily are always superior to those that are applied in one go.

right Some software applies vignetting using a Lighting filter, or similar tool. For this effect, an omni-directional light was applied over the model and cat, adjusted to produce only limited coverage, so the background was rendered dark.

above left and right The original portrait, on the left, has not been manipulated. But on the right, a very soft vignette – not too dark in the corners and extending well into the image – has been added and improves the impact by visually downgrading the hammock and the other unimportant details.

Fantasy effects

Few things are more entertaining than applying fantasy-type effects to an image. Add whirls and blurs, scatter rocklike facets, wildly distort the colors or shapes – throw every digital trick at your picture. The result may be hardly recognizable, but this may be exactly what you are after.

The beauty is that no matter how wild or bizarre the transformations you bring about, none of it need be permanent, provided you do not save any of the changes. You can experiment to your heart's content. But be aware that fantasy effects are a lot like those elaborate and intrusive scene-transition effects in video filmmaking: good practitioners make very little use of them and their appearance is almost the sign of an unskilled hand. On the other hand, who cares? As long as you mess up your image in the privacy of your own computer with the consent of the other party, the harm is as harmless as could be. And, of course, if you work on a copy image file, the original remains safely untouched.

The filtered image

You will find the majority of fantasy effects in the Filters menu of image-manipulation software. This function takes its name from the special effects filters made for film-based cameras – by fitting a variety of filters in front of the lens you could produce rainbow-colored kaleidoscopic images, blurs, starbursts and so on.

The problem with most filter effects, whether for film-based or digital photography, is that when they are applied uniformly to the entire image they add absolutely nothing to the pure beauty and naive simplicity of the naked human form. The trick is to work selectively, applying the effects

right This cropped-in image has the clean lines, clear shapes and simple colors that usually work best with filter effects.

only to limited areas of the picture, and to apply them to the more abstract imagery, such as close-ups of arms and legs. Whichever images you choose to work on, you can be certain that you will never run out of effects to try. Here are some hints to follow when working with filter effects:

- **Always work on a duplicate picture file. Never, ever apply filter effects to your one and only original shot.**

- **When learning, work with small files – not larger than 1 MB in size. This increases the speed with which your computer handles changes. Some filters take a long time to work even on the fastest computers.**

- **Try applying one filter after another rather than applying one, deciding you don't like it, and then returning to the basic image.**

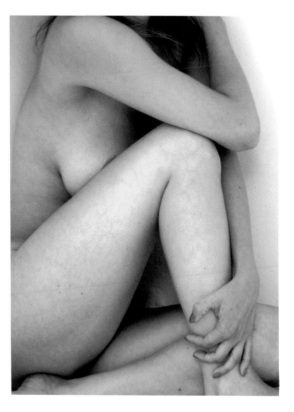

top row left to right A filter that seeks out large features and then applies color to the boundary areas works in a similar way to an artist drawing an outline. With such clean lines, the Colored Pencil filter has done a nicely graphic job, but notice the threat of too much detail from the skin tones.

Another artistic-effect filter works by dividing up the image into separate circles and then applying an even color to each circle, based on the most common color within. The effect tries to imitate the pointillist technique of early Impressionists.

A filter called Difference Clouds adds random blurs, darks and lights over the image. With this filter it is clear that anything but the simplest subject outlines would be destroyed, making the result unreadable.

bottom row left to right The Emboss filter is effective when used on images composed of graceful lines and smoothly gradated tones, such as those of nude figures. To create this image, the filter was applied and then all color removed. This is because the filter distorted some colors, particularly the painted fingernails. Finally an overall blue tone was applied to imitate metal embossing.

For a more subtle result, you need to use more advanced techniques. Here Layers – a feature not available in all image-manipulation software – was used to blend the image with the Emboss filter applied over the original. The results were subtle tones and alluring pastel colors.

Achieving this effect involved applying a Blur filter about a dozen times, followed by a few artistic-effects filters, and then adjusting the exposure and color saturation and two more artistic effects for good measure. What matters is that in the end the image does what you want it to.

Extreme curves

If you would like an example of image-manipulation software that has the bare necessities for working with images, look for the Curves control. It looks like a graph that, when you first open it, is a straight diagonal line. This line is a graphic representation of the way tones in the image are reproduced. By pulling the curve and changing its shape, you alter the way the image reproduces lights and darks, and everything else in between. It is a powerful tool, whether or not you know how to handle it properly. Small changes made to the graph give subtle effects, while large changes provide extremely dramatic effects that cannot fail to make an impression the first time you see them.

To understand how it works, open your image and call up the Curves control. Place your cursor on the curve (graph line), click and drag the curve. In some software, you can click on the curve, then press the arrow keys: this gives the best control.

Ensure that the Preview button is checked, if there is one, and observe the results of your efforts. In most software, if you click on the curve and then move off and click somewhere else on the curve, the previous point becomes an "anchor" that holds

below An informal shot of a model in a bath (top left) has all the right elements for applying unusual curves: it has large areas of single tones, strong and simple shapes – and is a good shot as it is. First, we applied a subtle curve that brightened and increased contrast in the middle tones (top right). The shape of the curve is bow-shaped, which works for many different images. Then we applied a wavy curve: this resulted in a dark image with sci-fi colors for the body (bottom left). By setting different curves for red and blue, but not green, we obtained a different type of manipulation (bottom right). The variations between all these images is so immense, it is clear you could experiment forever.

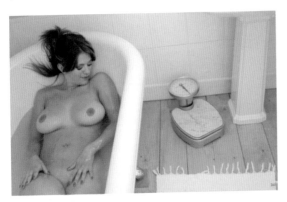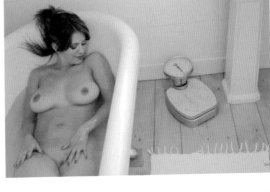

that part of the curve down while the rest of the curve can be manipulated. This is the basic power of the Curve control – it enables you to place a number of points down to fix one part of the tonal range while you alter others.

If you want to try more advanced tricks, you will see that Curves can be applied to the whole, integrated image or to the red, green or blue parts separately. This means you can apply one curve to the red, another to the blue and so on. Results of this can deliver the most unexpected changes in color from even the dullest parts of the image. What you thought were just plain gray or black areas can suddenly vibrate with strong hues. A word of warning: don't become so involved in playing with the software that you stop discussing the changes in the image with your partner, who should be included in the process, too.

For further details on using the Curves control, consult any of the many available books on image manipulation (see Resources, page 128).

Composites

For many, the height of image manipulation is the compositing of two or more images to create something unique and remarkable. In a light-hearted vein, placing Aunt Edna's head onto Granddad's shoulders can indeed be great fun, however you might find that frustration levels increase once you try more serious tasks. You soon discover that matching one image with another can be tricky, that the joins are extremely

difficult to make perfect, and that the technicalities that have to do with matching resolutions and colors get in the way.

When learning how to combine pictures it is a good idea to start with simple images, ones with clearly defined shapes. You will need software that supports Layers (sometimes called Composites, Floaters or Objects, depending on the software you are using). Then it is simply a matter of selecting the area of interest in one image, copying it and then pasting it into the composite image.

right This composite image was created by superimposing a flower photograph on top of a nude using Layers in the Photoshop application. The Opacity was then reduced so that the nude body could be seen through the flowers. Finally, unwanted areas of the top flower image were erased, following the curves of the body.

Scanning your work

Likely as not, somewhere you will have a box of photographs taken over the years. Or you may have a batch of negatives stuffed away in a drawer with no idea at all where the corresponding prints may be. The advent of digital photography does not render your earlier photography – your "legacy archives" or "legacy work" as it's known in the industry – obsolete. On the contrary, many people have discovered that digital photography can breathe new life into old pictures. Furthermore, you may prefer to use a film camera and, if so, there is no reason to feel that you are not invited to the party. By scanning your legacy work, you can bring these images into the digital fold. And you don't even need your own scanner. Here are the options to consider:

• Take or send your films to a laboratory to be scanned. The resulting files are then written onto a CD-ROM – formerly, the standard format was the Photo CD but now that anyone can read JPEG or QuickTime files, you are most likely to be given a standard CD with a folder containing all your scans. If you are a Macintosh user, be sure to tell the laboratory to give you a CD that is readily Mac-compatible.

below The original shot of this image was taken with a medium-format camera in an extremely hot hotel bathroom; it produced a very thin – that is, underexposed – negative. The image was rescued somewhat by scanning, and then digital manipulation to correct the tones.

- If you have many prints, you will need a scanner in order to turn them into digital files. Fortunately, one of the best-value pieces of digital equipment these days is the flat-bed scanner. Looking like a miniature, flattened photocopier, a scanner will convert your legacy prints for the price of a few packages of good-quality ink-jet paper. Good performance can be obtained from virtually any model from the major manufacturers (see pages 120–22). Some models will scan films as well, but results are variable – passable for color negatives, not very good with black and white negatives, and definitely poor with color transparencies.

- If you have lost the original prints from your negatives, there is no need to make new ones because you can scan the negative films directly. If you have many rolls of film, it is worth considering buying a film-scanner designed specifically for the job rather than a flat-bed scanner adapted for film-scanning (see page 121).

How to scan

Scanning can be an intimidating process if you have never done anything like it before. This is because two major aspects of duplicating your image – getting the right colors and the right size – can be tricky to accomplish. However, the main assurance you can give yourself is that you cannot really harm your originals through the scanning process itself. If the scan you produce is the wrong size or of inadequate quality, then don't be discouraged, simply scan it again.

Scanning is not exactly the most exciting activity, and because it's slow and rather boring, it is worth having other things to do while the scanner does its job – which could take several minutes or more. Unfortunately scanning does seem to tie up a computer so it slows down such related work as Internet surfing or printing.

Assuming you have already installed the appropriate software on your computer and are connected to the scanner, the basic steps to scanning are as follows:

1 Read the manufacturer's instruction book included with the scanner. Familiarize yourself with the operation of the scanner and the software controlling it. Don't forget the basic setup steps, such as removing or unlocking the mechanism (locked for safety during transport), before starting to use it. You usually have to turn the scanner on first before running the software.

2 Place the print or negative face down on the scanner, put the lid down and make a preview. This shows a quick view of the print to enable you to set the crop and position of the scanning area. Note that for most scanning equipment, the preview is in black and white.

BLEACHING OUT IMAGES

Colored images lose vibrancy and depth of color with exposure to light; this is because all colors are by nature "fugitive" – they tend to turn pale. Light levels used by scanners have hardly any effect on an image, but the very high levels of slide projectors or full sunlight can fade an image quite quickly. If you have a very precious color image, such as a fine-art watercolor, you should obtain advice before attempting to scan it.

3 Click on the image and drag out a rectangle which encloses the area you want in your scan. Now you need to set the size of the file. First set the actual printout size that you want. It's usually easiest to decide on, say, the length that you want and allow the software to work out what the other dimension will be to keep the proportions of the area you've selected.

4 Next you need to decide what resolution to set. Don't worry about the actual units, nor the precise numbers, but think about the use that you wish to make of the picture. If you want to make an ink-jet print, then you will want between 100 to 150 pixels per inch (2.5 cm) of the finished printed size. If you need higher quality, set more pixels per inch of the printed size, but do not set more than 300 pixels per printed inch.

5 Now make a prescan and set corrections. The prescan gives you a close approximation of what the final image will look like using the current scanner settings. If you don't like the image, this is your chance to alter the exposure, contrast and color settings to make it look better. Use the controls – usually presented as sliders or boxes into which you can type figures – to make the prescan image look as good as you can.

Today's printers actually get pretty near the mark first time, so all you need to do are small tweaks to refine the prescan. If you are frequently having to make large changes as the prescan looks very different from your original – then something is probably not correctly set up. Refer to your instruction book's troubleshooting section or visit the scanner's Web site for advice.

6 Make the full scan. You may be asked to give the scan a name and location – some software does this before the scan is made, some ask after. Also, some software quits itself after a scan, while others remain active. Obviously if you're going to do quite a bit of scanning, you will want to keep the software up and running – an option usually set in the Preferences window or dialog box.

7 And there you go: open up the scan file in your usual image-manipulation software and take a good look at it. If you're not happy with the results, pause to work out what you need to change, then scan again. If you haven't removed the original, all you have to do is run the scanning software again.

Printing out

It is no exaggeration that today's ink-jet printers offer unparalleled value for money. The quality possible from inexpensive machines is quite breathtaking. So do not hesitate – models from any of the major manufacturers are sure to be suitable.

Color accuracy

The main problem with using printers is controlling the quality of the color reproduction. The good news is that, straight out of the box, a good-quality printer working with a good-quality digital camera image is likely to produce a very passable result; such is the quality of control and exchange of information between manufacturers. However, it is what engineers call a "tight" system. It takes only a little leeway for an error to creep in, then – while the error may not be fatal – the result can be very unsatisfactory.

A complete solution to color-reproduction problems is technically involved and you should not expect to have to deal with it unless you're

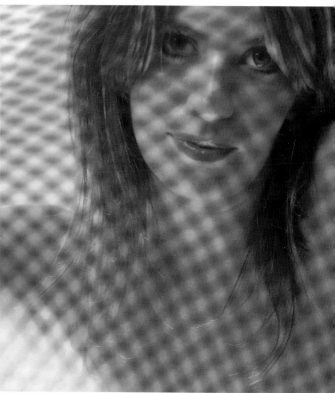

above This shot taken from a shower sequence is an example of a possible printing complication: the heavy, black areas look great in the image, but place big demands on the paper. The black color is made up not only of black ink but also other colors to ensure striking, rich results. Because of this, a great deal of liquid can be placed on the paper, which, unless it is good quality, may buckle and become soggy. Try reducing the strength of the black using the printer controls.

above right This type of image presents one of the toughest challenges for an ink-jet printer. First, it contains fine detail, such as the golden strands of hair in the center of the image. Then there are the subtle transitional tones of the out-of-focus netting. And finally, the delicate skin tones need to be accurately rendered. Fortunately, many relatively inexpensive printers are up to the task.

a serious enthusiast. But you can do smaller things to help yourself. The first is to realize that the image on the monitor is not – and is unlikely ever to be – a faithful, exact replica of the printed image. The second thing to remember is that, when the screen and printed images do not match, you must not try to adjust the monitor settings to make the images look similar. Instead, you need to adjust the image in your image-manipulation software. Never (unless you know exactly what you are doing) use the monitor controls.

The third most important factor is the quality of the paper. This is easy to control, but unfortunately the best option is also the most costly. It is difficult to produce a good image using inferior paper – that is like expecting a perfect painting job on a wall that is not cleared of cracks and holes. Not only the quality of the image but the overall color balance and contrast will vary with the paper you

use. Because of this, it is advisable to the use the best photographic-quality papers you can afford for even test prints, as tests on inferior paper tell you nothing about the adjustments you need to make in order to perfect the final image.

Working from defaults

Default settings are those that are supplied by the factory or manufacturer of the software, camera, printer and other such accessories. For the most part, images produced by default settings on digital cameras tend to produce images that look a little weak in color and contrast, perhaps a little too dark. By varying the settings on the printer controls, the printer will try to compensate for these deficiencies by slightly raising contrast and increasing color richness. Try selecting options indicated by names such as Photo Enhance, Photo Quality or Best.

If using the printer settings do not help, you will need to adjust your images via your image-manipulation software. Now, you will find that you make similar if not identical adjustments to one picture after another. For example, those photographs shot indoors under incandescent

lighting will need their high overall orange content reduced. Make a note of the settings that produce good results for one image, and then you can apply the same settings to all the images in the same batch or taken at the same time.

Printing composites

Not every picture has to fill the piece of paper, nor do you have to print only one at a time. And not every print need be the same size, of course. To save time you can group a few pictures together so that you print them in one go. You can turn to special software to do this – some printer manufacturers offer this as part of a bundle of software. Or you can simply create a large empty image which fills your sheet of paper. Then open up an image, select all of it, copy, then paste it into your large empty image. Adjust size to suit. Open up another image and repeat until you have filled the available space.

If you want colored borders, create your new image with a colored background – subtle sky blue or a black, for instance. Then paste in your image and adjust its size and position as needed.

Using Web services

The rapid growth in the infrastructure for digital photography means that you do not even need to have your own printer to make prints. If you have access to the Internet, you can send your images off to be printed at a remote site – perhaps hundreds of miles away – then receive them by mail a few days later. It works like this.

The best Internet service to have is broadband or Digital Subscriber Line (DSL): this leaves you permanently connected to the Internet and data-transmission rates are much faster than dialup speeds. If you have more than a few images to send, then a normal dialup connection to the Internet will keep you on the line for hours at a time.

HOW MANY CARTRIDGES?

You are at a disadvantage if you use a printer that works on only one or two ink cartridges. Many of your prints are likely to be colored with lovely warm skin tones, which use up great quantities of red and yellow ink. In no time at all, these colors will be exhausted and the other colors (cyan and black) will be largely untouched. If you have to throw the cartridge out now, you waste all the cyan and black ink, so it is preferable to use a printer that works on separate cartridges for each color.

Connect to one of the many printer services available over the Internet (see page 128), and then register and make an order, having first decided on the size of print, paper quality and the other details of printing required by the site. All you then need to do is pay and e-mail your files as an attachment. A few days later you should receive the prints by standard postal delivery. These Web-based printers are excellent for producing genuine photographs – those printed on gelatine-silver paper. They are also useful for creating extra-large or poster-size prints, which otherwise would mean investing in a costly printer that takes large-format paper sizes; some also offer printing on other media, such as fabric or canvas.

above First created in order to save on printing time, this composite image has interesting qualities and makes a complete image in its own right. The juxtaposition of shots with similar colors and lighting creates a cinematic effect, suggesting movement and narrative.

Actually, direct access to the Internet isn't even required. Simply save the files onto a medium that the laboratory accepts, such as a CD-ROM or Zip disk, and then mail it to the laboratory with an order form and payment (companies differ in the exact arrangements they make). Again, you will receive your prints a few days later, together with your original image files.

printing out **113**

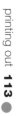

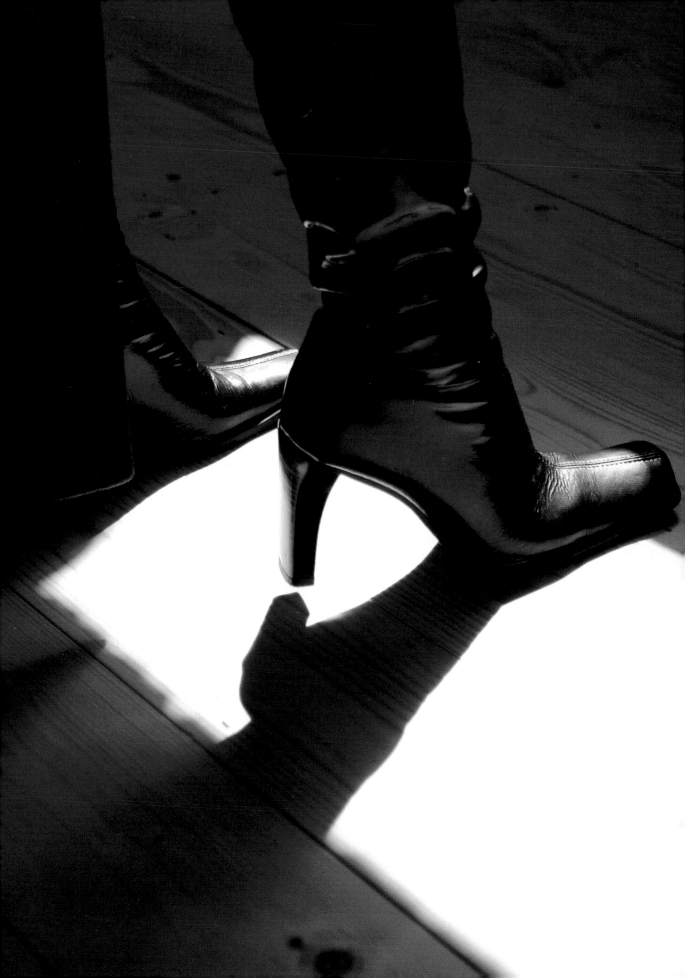

6 equipping yourself

It is possible today to buy truly leading-edge technology at very reasonable prices. A digital camera capable of producing semi-professional results can, for example, cost less than an airline ticket. And there are more and more second-hand cameras coming onto the market now that earlier generations of digital photographers are upgrading their equipment. The same goes for ink-jet printers – even the least costly can produce near-professional quality, given a good image to work from and good-quality paper. Certainly, ink for these printers can be expensive, but overall costs are still cheaper than having prints made by a photo laboratory.

The best advice must be: don't hold back. Don't wait for equipment to get better or cheaper. While both will happen, it's not worth waiting any longer because the market has reached a plateau and improvements in value-for-money have slowed down. The fact is that new equipment development is now driven more by marketing than by technological advances.

Digital cameras

Today digital cameras have turned the photographic world upside down, and while they are becoming increasingly inexpensive and capable of better and better results, your challenge is how to select from the dozens of models available.

First, decide what level of quality you realistically need – in terms of both image quality and quality of camera (including the range and complexity of controls that you will be comfortable with). Only when you are clear in your own mind on this point should you start to look at the ranges of cameras. You will probably find that one of the following cameras will suit your needs:

- **Bottom-level inexpensive** These cost less than, say, a midrange cell phone. They have few photographic controls, a fixed lens and produce low-resolution images. They are usually extremely compact and lightweight, and are suitable for taking small pictures for e-mailing. If this is all you want to do, then you might want to consider buying one of the new generation of cell phones that have a digital camera built in.

- **Entry-level inexpensive** These feature basic camera controls and are, therefore, easy to use. They usually have a fixed (nonzoom), nonautofocus lens. They offer acceptable image resolution – at around 1 mega (million) pixels – making them suitable for producing 4 x 6 prints. Some of these may be limited by their built-in image storage, which cannot be supplemented with a memory card.

- **Beginner** A camera catering to the amateur photographer will feature a zoom lens (2x or 3x ratio), making it a more versatile piece of equipment. It will have more photographic controls and the ability to accept memory cards. Resolutions of around 2 megapixels may allow up to 8 x 10 ink-jet prints, though image files of this size will be too large to be e-mailed conveniently. Many of these cameras offer a video mode to capture short movie clips. The cost of these is similar to an entry-level video camera, a high-end cell phone or a good-quality 35 mm film camera.

- **Midrange** Cameras in this group are significantly better than beginner-type digital cameras, and all offer a full range of photographic controls with good-quality zoom lenses – some with a range up to 6x – and resolutions of up to 4 megapixels. These cameras may come with a good range of software bundled in. Costs are similar to midrange 35 mm SLR (single-lens reflex) cameras or higher.

- **"Prosumer"** These professional/consumer cameras offer high levels of resolution (greater than 4 megapixels), excellent lenses and extra features. They have superior viewfinders, the ability to accept lens accessories that improve their versatility, and better software bundles. They are good value if you want the best, but you will need a lot of memory to capture images of this resolution. Costs are similar to a less-expensive professional-grade 35 mm camera.

above A good viewfinder is essential if you want to make precisely composed images such as this one, in which the focus has been carefully limited to the lamp rather than to the woman in bed.

Making a purchase

Here are a few points to keep in mind when you are deciding on a digital camera to buy:

Viewfinder Can you use it comfortably? Some cameras offer only an LCD (liquid-crystal display) screen at the back – a problem if your close-up vision is poor. And some viewfinders force you to look through a tiny lens, which is uncomfortable for all but quick snaps.

Computer compatibility Confirm that the connections and software are compatible with your computer and operating system. You do not want to have to update your operating system just to use your new camera. Obtain a guarantee that the camera can be returned if it is not recognized by your computer (particularly if you use a Windows or Intel-based PC). See also pages 124–25 for information on memory card readers.

CAMERA FEATURES

- **Autofocus: The camera itself focuses on the subject before taking the picture.**
- **Flash: This automatically fires to provide light when it is dark. It is useless when the subject is distant, and can give "red-eye" effects when illuminating close-up faces. Virtually all digital cameras have a built-in flash.**
- **LCD: A liquid-crystal display screen carries details of the options you can set and allows you to review pictures you have already taken. All but the simplest digital cameras have an LCD screen, but quality varies considerably. Some cameras have a tiny LCD screen under the eyepiece (sometimes called an "electronic viewfinder"), which allows the camera to be handled like an SLR camera.**
- **Megapixel: A measure of how much detail can be captured by the camera's sensor in millions of pixels. As a guide, 3 megapixels are sufficient for most uses.**
- **Viewfinder: This feature allows you to see what the lens is recording. The viewfinder could be an LCD screen on the back of the camera, a simple direct-vision optical viewfinder or more sophisticated types such as an electronic or SLR viewfinder.**
- **Zoom: This feature allows you to change how much is seen by the lens and, hence, the magnification of your subject. The majority of digital camera zooms cover the range between an equivalent to normal film cameras of 35 mm to around a 100 mm focal length – that is, from slightly wide-angle to around twice the magnification of a normal lens.**

Ease of use The menu selections on cameras can be confusing at first, but you should be able to get the hang of it within a few minutes in the store. If you find it too confusing, try another camera. If, for example, you often want to use the video mode, choose a camera that allows you to set it with just one click, not one that makes you navigate through a series of menus to get there. And, of course, always make sure the camera is comfortable in your hands and easy to hold.

Software and accessories Extras bundled with the camera can help you make up your mind about which camera to buy because the truth is that there is little to choose between closely competing models. So check if you get a battery charger or extra memory, or if you get useful software, such as image-cataloging or panorama-making software.

Computers

Most computers made since the new century are able to work with professional-quality digital images. However, I still use an Apple PowerMac I bought in 1996 for some of my scanning and picture work. The following features are the minimum specifications (I stress *minimum*) you need:

Operating system Windows 98 and later or Mac OS 8.6 or later. Using these operating systems may limit you to older digital cameras and software, however, but they are still perfectly usable.

RAM (random access memory) At least 128 MB, preferably 256 MB or more, is required.

Hard drive A capacity of 5 GB, but preferably 10 GB or more, is necessary.

Processor 300 MHz Pentium or equivalent (Windows) or any Power PC (Mac).

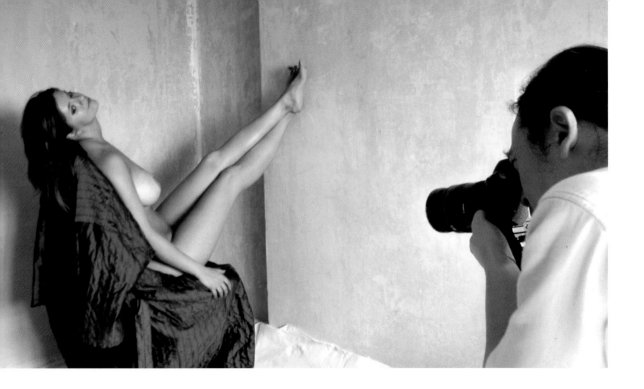

Interface A USB interface.

CD reader Used to install software.

Monitor & video card A 17" (43 cm) screen and card supporting a resolution of 1,280 x 960 pixels in millions of colors.

Upgrading from the basics
For a very good camera outfit, update your basic software and peripherals. The following specifications will not only produce high-quality results but also help you enjoy the process more because the system works rapidly and easily:

Operating system Windows XP or Mac OS 10.2 or later.

RAM (random access memory) At least 512 MB.

Hard drive A capacity of 50 GB or more, plus an auxiliary (backup) drive of 10 GB or more.

Processor 1 GHz Pentium or equivalent (Windows) or 500 MHz Power PC (Mac).

above Any camera – film or digital – can be used to create your private album, so long as you are comfortable with it and it works well.

Interface FireWire (IEEE 1394) and USB or USB 2 interface.

CD burner/reader Used to install software and create your own backup disks.

Monitor & video card A 20" (51 cm) screen and card supporting a resolution of 1,600 x 1,200 pixels in millions of colors.

Direct printouts
It is important to realize that you do not need a computer if you want to make prints directly from the camera. There are printers available that print directly from the camera or that accept memory cards (this way you don't have to connect the camera to a computer). If you go this route, your ability to modify images will be limited, but in terms of convenience it is unparalleled (see page 123).

Scanners

Available in a range of sizes, the most common types of scanner are known as flat-beds. Good-quality scanners can be obtained for less than a meal out for two at a decent restaurant and represent incredible value. Minolta, Canon, Umax, Microtek and Nikon are all reputable brands.

These are the main points to look for when choosing a scanner:

- **Size** Most machines can take 8½" x 11" originals and produce a maximum print to this size. But beware – the scan area may be a little smaller than this. In addition, the area with maximum resolution may be only a central strip that much smaller than 8½" x 11".

- **Resolution** Most scanners today scan to a resolution of 600 ppi (points per inch) or better. If you do not intend to enlarge your prints to any great degree (in other words, you intend to make mostly same-size scans), 600 ppi is ample and allows

above left and right A high-resolution image, seen left, will enable you to retain quality when enlarging your image, whereas a low-resolution image, seen right, will appear grainy and indistinct.

for an enlarged print of the original to be made. If you want to enlarge small transparencies (see the following point, below) then scan resolutions of 1,200 ppi and better should be your minimum scanner requirement. However, the cost of these machines can be much higher.

- **Transparency adaptor or panel** Flat-bed scanners are used for scanning originals, such as prints, by reflected light. To scan film or transparencies, you will need a scanner that can work using transmitted light (light that shines through the original). This calls for an adaptor or a light source located in the lid. Some more expensive designs have a special tray that slides under the scanner platen (the glass on which you normally place the original).

- **Connection to computer** Make sure that the scanner will connect to your computer and that you can return it to the store if, for some reason, your computer will not recognize the scanner. This is particularly important if you use a Windows or an Intel-based personal computer because incompatibilities are common. Most scanners use a USB standard connector, but more costly ones will offer FireWire (also known as IEEE 1394), which allows for faster operation. Some scanners can be powered directly from the connector cable and do not need a separate power cable. This is an added convenience.

- **Interface or driver software** If you can, have the scanner demonstrated to you before you decide to buy. The different software packages that run the scanner vary a great deal in quality and ease of use. Don't buy a scanner with complicated or time-consuming software to use, however inexpensive the machine itself

may be. Another reason to have the scanner demonstrated before you buy is to check how much noise it makes: while none are actually deafening, several versions produce whines and clicks that can be very irritating after a while. Also ensure that the driver is compatible with the operating system you are running on your computer.

Film scanners

If you are serious about scanning film – say to pull your collection of photographic originals into the computer – then consider purchasing a specialized film scanner. This type of scanner will give significantly better results with film than you could achieve with all but the most expensive flat-bed scanners. They display more variety in appearance than flat-beds, but essentially they are a box into which you feed individual slides or strips of film. Although they are costlier than flat-bed scanners, if you have, say, more than 50 shots you want scanned, it will be a good investment in the end. If you are going to all the trouble of scanning film, then you will want to obtain at least fair-quality scans. They are ideal for those with an extensive collection of material on film which needs converting to digital.

When deciding on a film scanner to purchase, consider the following points:

- **Resolution** A resolution of 2,700 ppi or better is required for good-quality work and the ability to make prints of at least 8½" x 11" size from 35 mm negatives or transparencies.

- **Film-holder** Check the quality and ease of use of the film-holder of the machine you are thinking of buying.

AUTOMATIC DUST REMOVAL

A growing number of scanners offer automatic dust removal. This does not mean that they actually clean your negative or transparency; rather, the scanner uses a combination of infrared light and software to detect and remove specks and tiny hairs from the scan data, helping to save you the work of cleaning up the scan later. This feature is most useful with film scanners, which considerably enlarge the original image, but it can also be found in flat-beds. If you intend purchasing a scanner, it is definitely a feature worth having.

- **Maximum density** At least 4 or better should be your aim. This measures the ability of the scanner to discern detail in the shadows of transparencies or in the bright areas of negatives.

- **Speed of operation** Scanners connecting to the computer via a FireWire or USB 2 connection are likely to run faster than those using a standard USB connection.

Printers

Modern ink-jet printers offer value for money that any other high-tech product would be difficult to beat. For very reasonable cost you can purchase a machine that will produce a print that only an expert can tell is not a true photographic print. So, the printer together with your computer give you a desktop imaging capacity that once required an entire laboratory to achieve. Another virtue of ink-jets should not be forgotten: besides giving you beautiful color prints, they can also produce colored type for letterheads, business cards or greetings cards. Epson, Canon, Hewlett-Packard (HP) and Lexmark are all reputable brands.

INK COLORS AND CARTRIDGES
One aspect of ink-jet printers that can be confusing is the relationship between the inks used and the number of cartridges installed. Some printers, usually the more expensive ones, use a separate cartridge for each ink, so if it is a six-color printer, you have to install six different cartridges. Many printers, however, use multiple cartridges – usually three colors in one cartridge – plus a separate cartridge for the black ink. In this example, a four-color printer uses just two cartridges.

Basic printers
For the cost of a handful of Zip disks or less than a dozen medium-priced music CDs, you can purchase a basic-quality ink-jet printer. These are virtually all full-color printers using at least three colored inks plus black. Print quality is adequate to very good for many purposes, such as illustrating letters or rough prints, but high-resolution pictures with smooth, subtle tonal or color transitions will not be rendered well on this level of machine. All basic printers produce images up to 8½" x 11" in size.

Photo-quality printers
For around double the cost of a basic printer there are numerous photo-quality printers available that can produce near-professional quality prints from files with good-quality data. In particular, these printers can produce nearly flawless tonal and color shading without banding or irregularities. In general, the more you pay the more features you get, such as the ability to print to the very edge of the paper, to print and trim from a roll of paper, or a faster printing speed.

But output quality generally rises with price, too. Look for a printer using six or more colors, as well as one offering the highest device resolution – usually quoted as, for example, 2,400 dpi (dots per inch) over a maximum output size of 8½" x 11" or a little larger. The best of these printers cost as much as a basic 3-megapixel camera. Pay a bit more and you can purchase a printer that can print up to 11" x 17" in size – but remember the cost of ink and paper will then shoot up alarmingly.

Printer uses
If you wish to have a wide range of uses for your printer – from photographic images to letters, newsletters, reports with charts and memos – consider one that is designed specifically for home business use. These produce good quality images

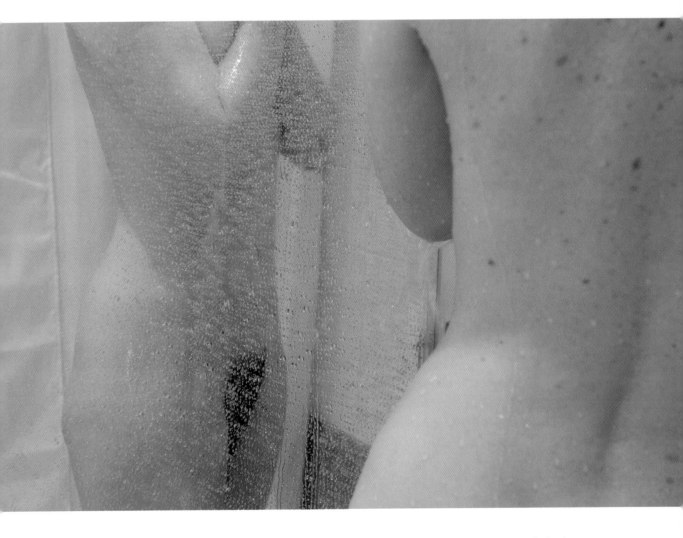

above When printing nudes, consider that an image made up mostly of skin tones will deplete yellow and red ink cartridges quicker than cyan and black.

but are much faster to use and the overall results often look better than those from printers that have been optimized for photographic quality alone.

Direct print

A growing number of printers do not need to be connected to a computer. You simply turn them on, insert a memory card or – in some cases – connect your camera, and you can print directly from the card or camera. Naturally the control you

can exercise over the image is very limited – you can, for example, select the images you want to print, rotate them and make minor visual adjustments, but not much else. Some printers have software that automatically makes corrections to an image to give it the best appearance. But good modern digital cameras take images that are often just about right and so need little or no correction, an you may find that failure rates from these are probably lower than with prints from film. Direct print printers are a little more costly than normal printers, but the convenience of being able to print without a computer can be a very valuable time-saving feature.

Other accessories

It is easy to be lured into a world populated by innumerable useful or, worse, essential gadgets. Too much time spent with your nose buried in a camera bag means you are more likely to miss the most interesting shots. So here are some really essential accessories to consider.

Battery spares and charger

Strange as it may be, some camera manufacturers don't supply battery chargers with their cameras. If you have to buy one separately, make sure it is correct for your camera and will charge the type of battery your camera uses and, preferably, is approved by the camera manufacturer. And so that your camera is not out of action while the battery pack is recharging, buy at least one spare. There is some law that states that your battery will always run out of power just when the creative flow is running high, so don't get caught. And if it takes less time for a battery to be used up than for an exhausted one to be recharged, it is prudent to have two spares at hand.

Memory cards

These are known as nonvolatile memory because they do not need an electrical source to maintain the integrity of the data they contain. All are small cards but their actual size and specification vary. Unfortunately there is a steadily growing number of different memory cards, but this will not concern you unless you use more than one type of camera. And if you do, it is wise to ensure the card types used by all your cameras are the same.

Unless you are a serious digital photographer, there is no need to select a camera on the basis of its memory card: all are more or less equally reliable, there is no significant variation in cost, and no card has yet proven to be significantly faster, or slower, in use than any other type.

The main difference lies in their size, but even then all are very small – half to quarter the size of a credit card, but rather thicker.

Cards offer different capacities – say 32 MB to 512 MB or even 1 GB and more. Calculate cost per MB (divide cost by the number of MB) and you will find that cards in the middle range of capacities – around 256 MB – tend to offer the best value per MB of storage.

SanDisk, Lexar, Delkin, Sony, Fujifilm, Kodak, Olympus and TDK are all reputable brands.

Memory card readers

When you are in the middle of a photo session it may not be convenient to take files directly off the camera when its memory is full. In this type of situation it is easier to take the memory card out and pop it into a memory card reader: a small device that connects to the computer. You can then copy the files to the computer while you put your second card into the camera and carry on shooting.

If you produce a lot of high-resolution pictures, consider buying a FireWire or USB 2 card reader that will send data to your computer quickly and save you time. Check which connections you have on your computer and if the cards will "plug and play" easily.

Once the files have been transferred to the computer, find a moment to conduct a random spot check of a few of them to make sure that the files are in good shape. To do this, open them using your usual image-manipulation program. Once you are certain they are reproducing correctly digitally, you can delete the files on the card and load it into the camera again to store new images.

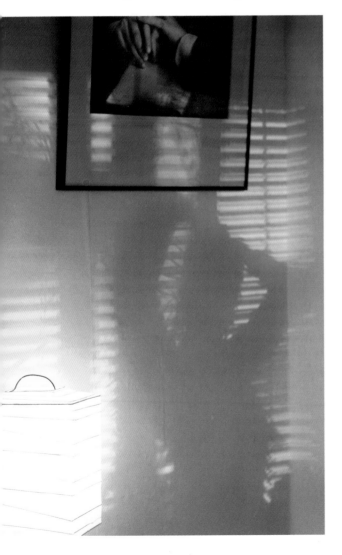

Portable mass-storage (PMS)

PMS devices are a cross between a computer with screen and a hard-disk drive, and they store around 20 GB of data from memory cards without the need for a full computer, making them useful for long-distance photo trips and field work. You simply slot your memory card into the device, press a few buttons and the files are copied over. A small screen allows you to review the pictures at low resolution so you can perform simple tasks such as deleting unwanted pictures or rotating images.

Back at home, connect the PMS device to your computer, usually through a USB or USB 2 cable, and transfer the files. Some PMS devices can play MP3 files back through headphones, too. They are quite expensive – about the price of a good-quality beginner's digital camera – but if you expect to take lots of pictures and believe in insurance against loss, especially when shooting away from home, PMS devices are invaluable.

Tripods

Photographers love to hate tripods: they do hold the camera steady for you – especially if you have a camera set on remote so that you can record both you and your partner (see page 76) – but they also impede free movement. For use at home or in a garden or backyard, you do not need a heavy, professional model. On the other hand, one that is so cheap that it cannot be tightened properly will be worse than useless. Examples of reputable manufacturers of inexpensive tripods include Slik and Velbon, while higher-quality and costlier tripods are made by Manfrotto, Gitzo and others.

left Experiment with the techniques and software facilities you have discovered here to take your private nude photography further, into the realms of the allusive, mysterious and oblique, in which your photography explores and comments.

Index

index **127**

Resources

Further Reading

Ang, Tom. *Digital Photographer's Handbook*,
Dorling Kindersley, 2002.
A wide-ranging introduction to modern photography,
covering camera techniques as well as image manipulation.
Helpful if you want to take your photography further.

Ang, Tom. *Photoshop for Photography*, Argentum, 2003.
A simple introduction to the photographic basics of the
best-known image-manipulation software. A good start
if you want to learn how to use the profession's standard
software application.

Ewing, William. *Body*, Thames and Hudson, 1994.
Brings some of the finest nude photography ever produced
together with an erudite and intelligent text. A must-have,
although the book itself is small in format.

Larg, Alex and Wood, Jane. *Beauty Shots*, RotoVision, 1998.
A good range of lighting setups clearly and concisely
described. Essential for learning how to duplicate setups
if you want to advance further. Other titles in the series are
worth a look, too.

Olley, Michelle. *Venus*, Carlton Books, 2000.
A mixed but generally inspiring collection of photography
of the human body, covering a wide range of styles. As
a photographer, you could do worse than imitate what
you admire.

Schefer, Dorothy. *What is Beauty?*,
Thames and Hudson, 1997.
Celebratory book with a splendid range of images of the
modern and the beautiful, with insightful quotes. Great for
inspiration and a tonic for the spirits.

Online Printing Services

The following are just some of the online print providers
who will accept image files via the Internet and then mail
back prints. Visit interest groups to check out which one
offers the best service.

USA:

Bonusprint www.bonusprint.com/us
Clear and easy to use. Site is also available in Spanish.

Ofoto www.ofoto.com
A Kodak company offering online print order services and
also photo sharing as well as accessories such as frames,
calendars, albums.

Photos on Yahoo photos.yahoo.com
General resource, including printing, also album sharing and
basic enhancements.

Canada:

Black's www.blackphotocentre.com
Well-known outlet with locations across Canada also
has online photo services, with special offers not available
in stores.

Kodak Picture Center picturecenter.kodak.ca
At this comprehensive site you can upload, manipulate, store
and share your photos online, as well as order customized
prints, albums and enlargements to be mailed back to you.

Photographers

The following is a brief list of photographers whose
work is approachable and whose styles and production
values are within the reach of the keen amateur. The
elaborate production techniques of masters such as
Helmut Newton, Norman Parkinson, Patrick Lichfield, Jan
Saudek and Robert Mapplethorpe may be a step too far
for me and probably, too, for the average keen amateur.

David Bailey: His early work is a brilliant *tour de force*
of the imaginative use of minimal props and spaces,
dramatic lighting and printing.

Amanda Eliasch: Playful and deceptively informal,
bringing the personality of the model to the fore, limiting
its emotional range.

Nan Goldin: Occupying an interesting no-man's land
between pornographic voyeurism and social documentary.
Shows what can be done with direct flash and a no-holds-
barred approach.

David Hamilton: This once highly fashionable photographer
was the master of gauzy images of girls – now out of favor
– but you can still learn lots from his work.

Jeanloup Sieff: Any monograph by this master of the
tasteful and nearly artistic erotic photography is worth
a close, admiring and self-educating look.

Acknowledgments

Tom and Wendy say: Many thanks to models Andria,
Olivia and Geoff. Also to Claire and John for the use of
their lovely home, especially to John for renovating their
bedroom at just the right time. And most of all to Judith,
our inspiring editor and friend, for commissioning this book.

Tom says: And special thanks must go to the
biggest inspiration and the start of it all – my
wife and partner, Wendy.